CHAMPION ANIMALS

Sculptures by Herbert Haseltine

by Malcolm Cormack
Paul Mellon Curator, Virginia Museum of Fine Arts

VIRGINIA MUSEUM OF FINE ARTS / RICHMOND

This book is made possible by The Mellon Endowment Fund.

Library of Congress Cataloging-in-Publication Data

Haseltine, Herbert, 1877–1962.
 Champion animals: sculptures by Herbert Haseltine/
introduction by Malcolm Cormack.
 p. cm.
 Includes bibliographical references.
 ISBN 0-917046-43-9
 1. Haseltine, Herbert, 1877–1962—Catalogs. 2.
Animal sculpture—Catalogs. 3. Virginia Museum of
Fine Arts—Catalogs. I. Cormack, Malcolm. II. Virginia
Museum of Fine Arts. III. Title.
NB237.H36A4 1996
730'.92—dc20 95-52719
 CIP

ISBN 0-917046-43-9
Printed in the United States of America

Produced by the Office of Publications, Virginia Museum of Fine Arts,
2800 Grove Avenue, Richmond, Virginia 23221-2466 USA

Photographs by Katherine Wetzel
Edited by Rosalie West
Book Design by John Hoar
Composed by the designer in Quark Xpress
Type set in Minion
Printed on acid-free 80 lb. Warren Lustro Dull text by
Progress Printing, Richmond Virginia
Binding by Advantage Book Binding, Inc., Glen Burnie, Maryland

FRONT COVER: *Sudbourne Premier* (see pp. 23–29).
BACK COVER: *Sandringham Ewe No. 10 of 1921* (see p. 81).

Contents

Foreword

Herbert Haseltine was delighted when Sir Theodore Cook, editor of *The Field* magazine, had the idea in 1923 of "finding someone to buy the whole collection of the British Champion Animals and to present it to the Nation. The subject being typically English, with its combination of interest both from the agricultural and artistic point of view, it would in his opinion be most appropriate and acceptable to the public."

Cook's plan never came to pass, but the collection's final home at the Virginia Museum of Fine Arts in Richmond seems an appropriate alternative. Virginia is a state whose citizens possess both agricultural and artistic interests, and the Virginia Museum of Fine Arts is well situated to serve art lovers and animal lovers alike. Close to the Virginia State Fairgrounds, the Science Museum of Virginia, and the area's many fascinating museums, the Virginia Museum of Fine Arts is accessible through its outreach programs to the surrounding countryside as well as to urban areas both in the state and beyond. Furthmore, as a state-supported institution,

the Museum has the kind of presence in the public domain that Haseltine and Cook would have appreciated.

Haseltine would also have felt a kinship with the patron responsible for bringing his sculptures to the Virginia Museum of Fine Arts. When Paul Mellon donated the collection in 1986, he was active in the raising of thoroughbred horses and cattle (primarily Angus, Herefords, and Shorthorns, all breeds represented among the British Champions) on a country estate not unlike those in Britain where Haseltine created his sculptural models. Mr. Mellon's interest in animals, however, has never been exclusively agricultural. He speaks often of his love for hunting, racing, and the art and literature that helped to foster his enjoyment of these sports. As he has written in his recent memoir (*Reflections in a Silver Spoon,* 1992), the source of his interest in racing was his "love of the horse, the well-kept, well-trained, beautifully moving horse, the horse as an object of art." In donating these sculptures to the Virginia Museum of Fine Arts, Paul Mellon has helped visitors, not only from Virginia but from around the world, to see familiar animals in a new and appealing way, as fitting subjects of art.

We are grateful to Marshall Haseltine, the artist's son, who has allowed his father's memoirs to be edited and arranged by Malcolm Cormack to give an original view of how these sculptures came into being. The publication of the book was supported by Mr. Mellon as the latest in a succession of educational and publishing projects he has nourished throughout his life. We trust it will widen the audience for this delightful collection as well as provide readers with a glimpse of the man who created it.

Katharine C. Lee
Director
Virginia Museum of Fine Arts

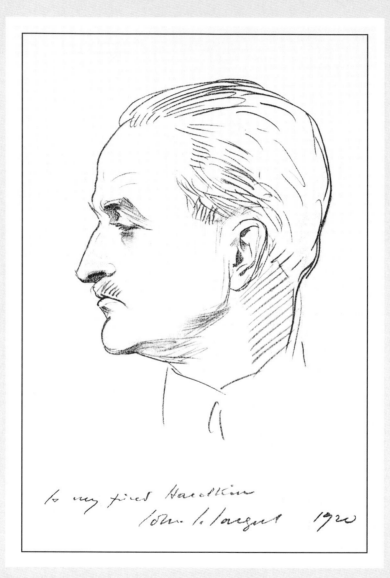

Drawing of Herbert Haseltine, 1920, by John Singer Sargent (1856–1925)

Introduction

The Virginia Museum of Fine Arts is fortunate to possess, through the generosity of Paul Mellon, a unique set of sculptures by Herbert Haseltine. They date from a particular period in his career, beginning in 1921 and lasting for more than ten years, when he became preoccupied with a quest for perfection. His early work as an animal sculptor had already led him to investigate the possibility of sculpting an ideal horse, but then, in 1921, he conceived the idea of using as models a series of outstanding animals that had won prizes at the leading agricultural shows in Great Britain. The set, which was eventually named the *British Champion Animals*, comprised draft horses, a hunting horse, a polo pony, sheep, cattle, and pigs. Producing these sculptures, which were without precedent at the time, was a task to which he devoted his creative energy. It is the purpose of this book to see how he realized his aim.

Whenever possible, Haseltine's own words—in the form of unpublished excerpts from his memoirs—have been used to describe his methods and activities. However, some further description of his life is necessary to provide a context for his work.

Although Haseltine was an American—his father was the American painter William Stanley Haseltine (1835–1900), his paternal grandfather a prosperous Philadelphia businessman—he was born in the Palazzo Altieri in Rome. Like his father, he had a cosmopolitan upbringing; both were examples of the many expatriate American artists and writers, such as John Singer Sargent and Henry James, whose training and professional careers were conducted mainly in Europe. Herbert, again like his father, attended Harvard and returned to Europe to study drawing and painting in Germany, in Herbert's case at the Royal Academy of Fine Arts in Munich, and then in Rome between 1896 and 1900. In 1900, he went to Paris and for two years attended the Académie Julian. He then moved back to Italy, where his main interests were centered on horses, through his activities on the polo and hunting fields. As he said, "I was unconsciously studying the conformation and movement of horses, which served as a foundation for more serious work in later years."

In Paris, in 1905, he had sought the advice of Aimé Morot (1850–1913), an academic painter of battle scenes, history paint-

ing, and portraits. Morot encouraged the careful attention to detail that had also marked William Stanley Haseltine's work. Herbert began to make clay models and found he had an aptitude for it; his first exhibited work, at the Paris Salon of 1906, was a sculpture with animals: a vigorous group of polo players called *Riding Off* that received an Honorable Mention. This group, a cast of which is owned by the Virginia Museum, shows how quickly Haseltine had

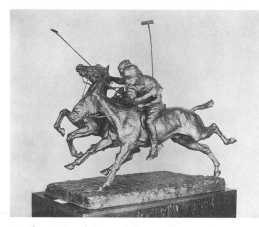

Herbert Haseltine, *Riding Off,* 1906, bronze, 28 x 22 x 40 inches. Virginia Museum of Fine Arts, Gift of The Honorable David K. E. Bruce, 36.13.1.

absorbed the realistic tradition of the French *animalier* sculptors. His social connections brought him commissions for further horse subjects, including Prince Schoenburg-Hartenstein on his hunter, King Edward VII's charger Kildare, and Queen Alexandra's carriage horse Splendour. In 1909 he modelled,

as a group, Harry Payne Whitney's Meadow-brook polo team in Long Island. Whitney's wife, Gertrude Vanderbilt Whitney, was herself a sculptor, and Haseltine was to benefit from her patronage and advice.

In the same year as the Whitney commission, Haseltine married an English-woman, Madeleine Klein. They settled in Paris and had two children, Helen in 1911 and Marshall in 1912. Eventually, Haseltine was to become one of a group of American sculptors who worked and studied in Paris, often using the same Parisian foundries, Valsuani and Rudier. The group, which met socially, included Paul Manship, a friend of John Singer Sargent's (Sargent later produced a portrait drawing of Haseltine, facing p. 1); Frederick MacMonnies; Anna Hyatt Huntington, who used a Percheron mare for her sculpture of Joan of Arc; Malvina Cornell Hoffman, a cousin of Haseltine's; and Albert Laessle, among others. The only one who had not come from a comfortable American social background was Jo Davidson, but his "head hunting," as Will Rogers described his portraiture, brought him into contact with socialites, and he was to become a friend of Haseltine's. They worked together on an equestrian portrait of General Pershing after the First World War.

Before the war, Haseltine had produced a series of bull-fighting groups from his experiences in Spain, but at the same time he had already begun work on a sculpture of

an idealized thoroughbred horse, the concept of which lay behind much of his future work. The war, however, interrupted both his sculpture and the social round he enjoyed in Paris. He became a special assistant to the American Ambassador in Paris, inspecting prisoner-of-war camps, and when America entered the war in 1917, he organized its first camouflage section.

His war experiences resulted in two groups based on his love and experience of horses, *Le Soixante Quinze* (Field Artillery), and *Les Revenants* (The Phantoms), a group of gassed and injured horses. Another memorial to the war was his sculpture of a solitary riderless horse titled *The Empty Saddle*, commissioned for the Cavalry Club in London to commemorate lost members.

After the war, his friend Jo Davidson recommended that he should study the Egyptian sculptures in the Louvre: "My attention having been drawn to the plastic beauty of Egyptian sculpture my work underwent a complete change."

In contrast to the detailed naturalism of the *animalier* tradition in which Haseltine and many of his American peers had previously worked, the hieratic stylization and highly finished ancient examples in the Louvre, and also in the British Museum in London, made a significant impression on him. Hard polished stone and linear incised detail, together with lapis lazuli and rich surface decoration, were attributes of sphinxes and other ancient animal sculptures he had admired, and are to be seen in his next major project, the British Champion Animals.

Up to that moment I had made more or less servile copies of what lay before my eyes, not daring to branch out into anything too personal, my earlier training having consisted in ultra-accurate drawings and endless measurements—even the use of photographs and plaster casts made directly from nature.

It was the method employed by Gérôme in his sculpture and transmitted by his practitioner Peyranne.

In later years I grew out of this technique and, I am thankful to say, got it out of my system. Yet in a way, it was not time wasted, for it laid a foundation of thoroughness, as the playing of scales does for a musician; to a certain extent it corresponds to the Italian saying: *Impara l'arte e mettila da parte.*[sic] (Learn your art, then put it aside.)

Haseltine makes further comments about the tyranny of measurements in his discussion of the genesis of the "composite type." It is interesting to note, however, that he never completely abandoned traditional French studio practice. He continued to draw and take photographs and measurements; for example, in the case of the sculpture of *Rhum*, the Percheron stallion, he describes how the quiet temperament of the horse allowed him to "take measurements of his legs and trace the outline of his hoofs on a piece of cardboard with perfect confi-

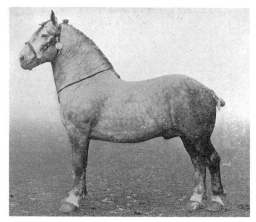

Percheron Stallion, Rhum

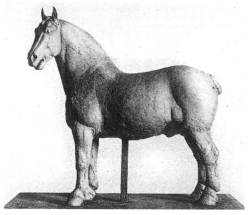

Haseltine's plasticine model of Rhum

dence." He also describes the regular help he received in Paris from an English photographer, H.A.V. Coles, who took detailed photographs of each stage in the modelling process.

His quest for an ideal thoroughbred horse had already prompted thoughts toward idealized forms, but when he began a model of King George V's champion Shire horse, Field Marshal V, he had the idea of a whole series of perfect models of perfect animals. The series thus begun in his Paris studio in 1921 took him all over Great Britain, visiting the owners and their stables and farms to make plasticine models from life. As his memoirs reveal, the results were often hilarious. Plasticine, by the way, is the proprietary name for a modelling substance introduced in 1895 and used a good deal in schools. (It is sometimes known as plastelene in the United States.) Being oil-based, it has the advantage over clay in that it does not dry out and become brittle, but remains malleable and can be used again and again. It is, however, easily deformed with pressure, so that Haseltine was forced to produce complicated methods to ship his models back to his studio in Paris, as he described in his diaries:

> Once I had obtained an impression of an animal sufficiently vivid for me to continue without the model, I would pack the plasticine model very carefully (a system of packing of my own) using pads of cot-

ton wool and flexible bandages, called *velpo* in France, and then encase the model in a box with a door in the front of it; it was firmly attached on its wooden base to the bottom of the box by means of bolts and screws. I usually got the local carpenter to make these boxes for me, and, with hardly an exception, all my models arrived safely at my studio in the rue Dr. Blanche in Paris. Usually I would bring over these consignments myself. After assembling four or five models in London, each in its respective case, I always tried to get the cases packed into one of those sling-boxes that are lifted by a crane from the train at Dover or Folkestone onto the Cross Channel Steamer. At the station in Calais and at the Gare du Nord in Paris, the station and customs officials had been advised about the arrival of the cases and gave every assistance to get them out of the train and on to a waiting lorry engaged to convey them to my studio. Baron Robert de Rothschild, being the Director of the Nord R.R., and who owned a number of my bronzes, was instrumental in facilitating these arrangements.

Apart from the ease with which his social connections facilitated his tasks, he also had other connections, as his memoirs reveal:

During my first summer in England, when I first arrived and started work on the B.C.A. [British Champion Animals], I had taken a flat in London in Savile Row [near fashionable Bond St.], together with my cousin Carroll Carstairs [at that time the director of Knoedler's, a leading inter-

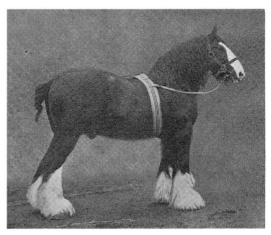

Shire Stallion, Harboro' Nulli Secundus

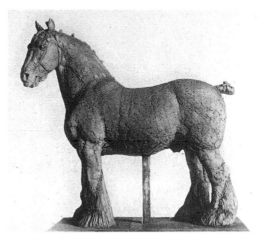

Haseltine's plasticine model of Harboro' Nulli Secundus

national art dealership]. He was then courting a very attractive young girl, and on my return to the flat after one of my working trips, I used to be regaled with long and passionate dissertations about her beauty and charms.

During one of my brief interludes in London, I suddenly found myself immobilized by one of my violent attacks of lumbago. I had invited my great friend E.V. Lucas, the author [who was to write a preface to his works], to dine with me that night. The dinner, which was served at my bed-side, had been prepared by that excellent culinary artist, Mrs. Mayes. Oysters from Buck's, followed by a chicken such as only she could roast.

His exhibition of some of the models at Agnew's in 1921 had an interesting complementary exhibit of the phases through which his models passed before the finished object emerged, which was described in the catalogue. From his description we can learn that his method of casting by the lost wax (*cire perdue*) process, and patinating with the help of well-established foundries in Paris, such as the Valsuani and Rudier, was quite conventional. Haseltine also employed professional stone carvers (as Rodin had), who could carve his models in colored stones to approximate the coats of the animals. They could enlarge and then, if necessary, decrease the size of the models in the traditional way. He mentions Haligron *père* and *fils* in this connection. At least on one occasion, however, Haseltine specifically states that he carved the Aberdeen Angus Bull, *Black Knight of Auchterarder*, in black Belgian marble, which is now in the Virginia Museum of Fine Arts.

The complete set of the British Champion Animals that is now in the Virginia Museum was commissioned by Marshall Field in 1925. Field wrote to his brother Stanley on October 29, 1925: "I have just entered into a contract to buy a set of twenty-six sculptures of British champion animals from Herbert Hazeltine [sic] for the Field Museum. These are not only great works of art—as I believe Herbert Hazeltine is one of the greatest sculptors today—but I think will also be very interesting from a natural history point of view."

As the individual dates of the sculptures demonstrate, Field had to wait until 1933 for them to be finished, and he ultimately received nineteen, not twenty-six. Haseltine's memoirs trace the various versions that he produced during the 1920s and 1930s, some cast in bronze, some carved in various stones. A number have subsequently appeared on the market. In 1934 the Field set was donated to the Field Museum of Natural History in Chicago, which sold them to Paul Mellon in 1986. In the same year Mr. Mellon generously donated all but one of the sculptures to the Virginia Museum of Fine Arts; *Percheron Mare: Messaline and Her Foal* followed in 1993. It is clear from Haseltine's comments on this latter piece that he cast it in plaster from

the plasticine model and then made squeeze models with plasticine, on which he worked further before it was cast and then carved in Bardiglio marble. All of the Field set were one-third life size.

This refining process, and idealization of the forms, based as they were on his knowledge of Egyptian, Assyrian, and Oriental sculpture, can be compared with the approach of other artists of the 1920s. For them, the simplification of "significant form" and incised textures were part of a modern rebirth of sculpture. In this context, Henry Moore and Jacob Epstein come to mind. Haseltine, however, was never so consciously "modern." His traditional bounds were too tight:

> I used to pay frequent visits to the Louvre to study the great Egyptian School, the Assyrian *bas-reliefs*, the early Greek sculptures, and masterpieces of Chinese art. When in London, I spent many hours at the British Museum, where I steeped myself in the masterpieces of these same great schools.
>
> I did not, I must confess, take much interest in the average exhibitions of modern sculpture—I usually found them depressing, whereas the masterpieces of the Egyptian, Assyrian, Greek and Chinese schools were exhilarating and stimulating.

Yet it is not claiming too much to place his work in the context of the 1920s in Paris with the stylization of Art Deco, and the creation of *objets de luxe* for a wealthy clientele.

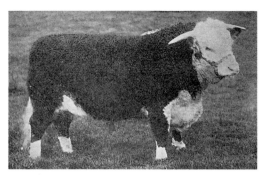

Hereford Bull, Twyford Fairy Boy

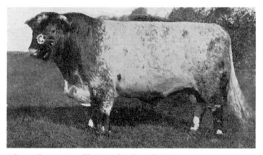

Shorthorn Bull, Bridgebank Paymaster

Marshall Field, in the letter to his brother Stanley quoted above, also noted that "English breeders of blood stock have endorsed the exhibition in London most highly and all say that the animals are a very favorable representation of the blood stock of today. A hundred years from now I think it will be very interesting for breeders to compare. . . ." It has not yet been a hundred years since Haseltine did his work, but according to contemporary experts some of the breeds he modelled have indeed changed in response to the changing roles of animals in human life. Cattle breeds have become more specialized, so dual-purpose cattle

like Lily Charter 2nd are much less common. And draft horses—the Suffolk Punches, the Shires, and the Percherons—tend to be less muscular today than they were in the 1920s since they do less work, although their massiveness is still valued. However, other breeds, especially pigs, are less hefty; human beings in the late twentieth century want their animals to reflect the same svelte ideals they themselves are striving to attain.

Haseltine's other work during the 1920s comprised modelling horses for Mrs. Payne Whitney, George Widener, and Averell Harriman. In 1925, following an invitation from the Maharaja of Nawanagar in India, he produced a twelve-foot high equestrian portrait of the sixteenth-century founder of the Nawanager dynasty, mounted on a plinth designed by his friend, Sir Edwin Lutyens, the architect of British Imperial India. This statue is still at Jamnagar. He produced other Indian works notable for their rich embellishment, as well as further one-man exhibitions at Knoedler's in New York, and the Fogg Museum at his alma mater, Harvard, from whom he received an honorary degree.

Haseltine never completely abandoned his quest for a harmonious synthesis of realism and the ideal, even after he had delivered his set of the British Champion Animals to Marshall Field in 1934. He had first shown his original versions at the Galerie Georges Petit in Paris, in June 1925, followed by a show at Knoedler's Gallery in London in July/August 1925 and another one at Knoedler's in London in 1930. The Field set was shown at Knoedler's, New York, in 1934. Further examples were shown at Carroll Carstairs' Gallery, New York, in May 1936 (as indicated earlier, Carstairs was Haseltine's cousin and had been previously a director of Knoedler's). He went on producing other versions in a variety of materials, and fifteen were shown at Baltimore in 1951 in an exhibition of thirty-three of his works. Partridge's in London included some of the animals in an exhibition of 1953, and the large retrospective of 1955 in Paris at Galerie Jansen had a whole section devoted to the British Champion Animals, which comprised thirteen out of a total of thirty-five works.

During the 1930s Haseltine received a number of commissions for famous horses and visited India again in 1938. When the war came to France he left for the United States where, among other commissions, he worked on a heroic model of the famous racehorse Man O' War. As the "greatest horse," Man O' War reappeared with "the greatest American" (George Washington) in the equestrian monument at the National Cathedral, Washington (1955). At the end of the war Haseltine embarked on a large statue of Field Marshal Sir John Dill for Arlington National Cemetery.

Haseltine returned to France in 1946.

Academic honors came his way: he had been made a full member of the National Academy of Design in the United States, and in 1956 he was elected to the French Académie des Beaux-Arts. He died in Paris on 8 January 1962.

Haseltine's work, as we have seen, did not entirely fit in with either academic or consciously modern sculpture. The general movement in American sculpture from public memorials to private works—described by Daniel Robbins as a shift from the public world of the "statue" to the private, intimate world of "sculpture"—was slightly at odds with Haseltine's career, which embraced both. Nor did Haseltine entirely follow the modern tendency, again described by Robbins, toward "rightness of carving," for although Haseltine did do some carving and modelling himself, he also used professional carvers and foundries.

In 1856, Erastus Dow Palmer saw that "the mission of the sculptor's art is not to imitate forms alone, but through them to reveal the purest and best of our nature. And no work in sculpture, however well wrought out physically, results in excellence, unless it rests upon, and is sustained by the dignity of a moral or intellectual intention." Daniel Robbins had seen these ideals behind most conservative American sculpture of the first half of this century, and in this respect Haseltine would surely have agreed; but in the purity of his forms he remains the "observant stranger," as Henry James described someone who had caught a glimpse of a bold new world.

Malcolm Cormack
Paul Mellon Curator
Virginia Museum of Fine Arts

ACKNOWLEDGMENTS

Many people deserve thanks for helping to bring the British Champion Animals to the printed page: Marshall Haseltine, the sculptor's son, for encouragement and permission to quote from his father's unpublished memoirs and to reproduce Sargent's portrait of his father; Beverly Carter, Assistant to Mr. Mellon, for a complete transcript of the memoirs and much information; Susan Menconi, previously with Hirschl and Adler Galleries, New York, for excerpts from the memoirs; Gaillard F. Ravenel, National Gallery of Art, for the display of the sculptures; Jackie Dureski, Best Secretarial Services, for word processing; Christina Grindon of *The Field*, Elaine Hart of *The Illustrated London News*, and Susan Marcotte of the Smithsonian Institution, for comparative photographs; Sue Mullins and Clay Roberts, State Fair of Virginia, for insight into the distinction between the British Champion Animals and today's honored breeds; and staff members of the Virginia Museum of Fine Arts: Mitzie Booth, Caryl Burtner, Diana Dougherty, and interne Sara Ward, Collections; Howell Perkins, Photographic Resources; Denise Lewis and Katherine Wetzel, Photography; John Hoar, Jean Kane and Dylan Steele Kane, Sarah Lavicka, Monica Rumsey, Amy Van Buren, Rosalie West, and Michelle Wilson, Publications; and Andy Kovach, Frank Milik, Maureen Morrisette, Mary Sullivan, and Roy Thompson, Registration.

The British Champion Animals

In the early spring of 1922, Jo Davidson brought Jimmy Alison, editor of the Field Press, to my studio [in Paris]. Alison displayed great interest in my work, particularly in the unfinished model of Field Marshal V, which, as I said before, was much more stylized and quite different in treatment from the other models standing about the studio.

Suddenly an idea struck me—why not make a series of such animals? Of those I had seen at the shows of the Royal Agricultural Society of England? Why not make a series of "Champions" of different breeds? Horses, cattle, sheep and pigs? I turned to Alison and Davidson and told them what was passing through my mind.

"That is a wonderful idea of yours," said Alison, "and if you follow it up, I think I could give you a good deal of help in the matter—help in putting you in touch with breeders and owners of the best livestock in the country. *The Field* would help you in every possible way, though not, of course, financially. You would have to pay all expenses yourself. Think it over and write to me in London, when you come to a decision."

In my mind, I had already firmly decided what to do. That night I could hardly sleep, thinking of the idea which I had conceived; I waited several days before writing to Alison; then, being unable to stand the suspense any longer, I wrote him that, after mature deliberation, I had decided to undertake the production of this group, and suggested calling it the *British Champion Animals.*

I followed up my letter with a visit to London, where Alison introduced me to Sir Theodore Cook, editor in chief of *The Field*, with whom I had a long interview, during which I described our plan of campaign.

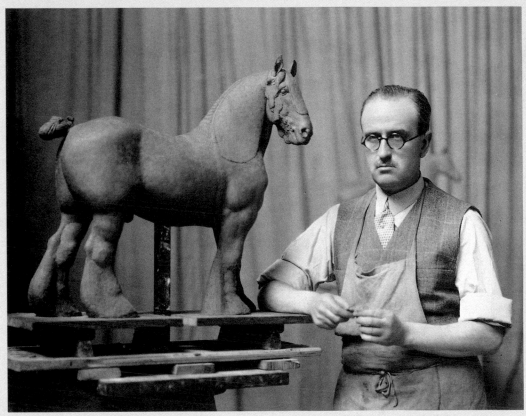

Herbert Haseltine in his Paris studio, ca. 1921, with clay model of Field Marshal V.

He in turn consulted the specialists in the different fields of sport and agriculture, the writers of turf and hunting field matters, and the experts on polo ponies, draught horses, beef and dairy cattle, sheep famed for their wool and those for their meat, and lastly pigs. Breeds were tentatively decided on, while Sir Theodore Cook wrote to their owners.

The work, begun with Field Marshal V at Sandringham in the summer of 1921, ended in my studio in Paris with *Field Marshal V* in the summer of 1933—the first to begin and the last to finish. The original provisional list included, besides the King's Shire stallion mentioned above, another Champion Shire stallion, Harboro' Nulli Secundus, owned by Mrs. Stanton of Snelston Hall, Derbyshire, who had won many prizes with him.

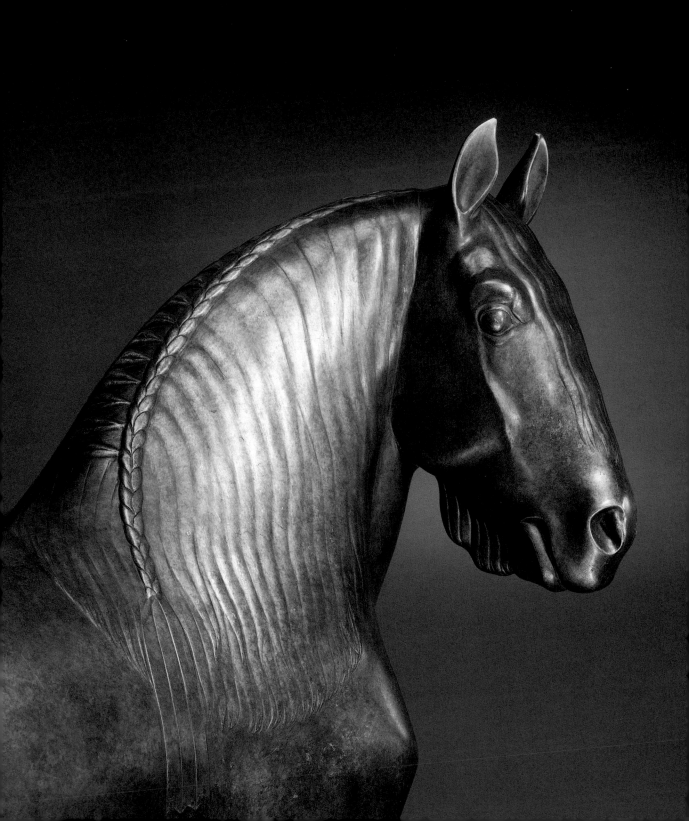

SHIRE STALLION

Field Marshal V

Shire Stallion:
Field Marshal V

Chiseled bronze plated with gold,
mounted on porphyry base
28 x 11 ½ x 26 INCHES
(71.1 x 29.2 x 66 CM)
AFTER 1921-23
VIRGINIA MUSEUM OF FINE ARTS,
THE PAUL MELLON COLLECTION, 86.131

SIRE: *Champion's Clansman.*
DAM: *Early Primrose. Foaled 1917.*
Bred and owned by King George V,
Sandringham stud. First and
Champion at the Show of the Shire
Horse Society, 1920 and 1921.

The happiest moments in an artist's life are those, I suppose, when he gets an inspiration, and when he is able to carry it out successfully to its completion.

Up to the time of my London Exhibition in Agnew's Gallery during 1921, I had devoted my efforts to making groups of animals in motion, such as my polo group, and those of the bull-fight groups, also two "war" groups, i.e., *Les Revenants* and *Le 75*, later called *Field Artillery*, and also several orders for depicting in bronze or stone some portraits of race horses, hunters and polo ponies; my London Exhibition contained examples of all these subjects.

If it had not been for a visit to that year's show of the Royal Agricultural Society, I would probably never have thought of doing anything different in that particular line of animal life.

I arrived at the beginning of the Cart Horse parade, and was overwhelmed by the beauty, power and sculptural massiveness and magnificence of that group of Shires, Clydesdales, Suffolk Punches, and Percherons.

Just at that time I had to go to Newmarket to my friend Peter Gilpin, to make a model of Comrade, winner of that year's Paris Grand Prix. I always stayed at his house when in Newmarket.

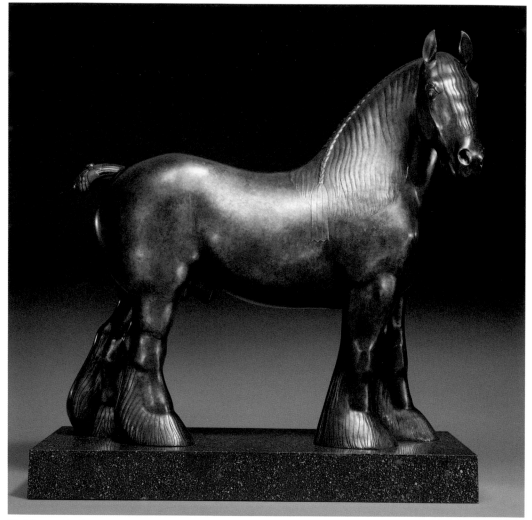

Field Marshal V

One evening after dinner, I began talking about the Cart Horse Parade, which had impressed me so deeply, and told him how much I would like to have a chance of making a model of one of those beautiful animals.

"That can easily be arranged," said Peter. "One of my best friends is Sir Walter Gilbey, this year's President of the Shire Horse Society. I will be only too glad to give you a letter to him."

A few days later I presented this letter at his spacious and old-fashioned office at the Pantheon in Oxford Street; it consisted of a huge hall with innumerable desks to the right and left of the central aisle, and must have been built and installed some time in the early eighteenth century.

Sir Walter, like his father before him, was the head of the famous wine and spirit business, and also like his father a great lover of horses; he received me most affably, and, after reading Gilpin's letter, asked me what he could do for me. I explained that I wanted to have a chance of making a model of what he considered to be a fine example of a Shire horse.

"This year's Champion Shire horse is Field Marshal V, belonging to the King. If you like, I will ask permission of His Majesty to let you make a model of the horse."

Permission was granted, and a few days later I took the train to Sandringham, where I was met by Mr. Beck, the Agent, who had reserved a room for me at the Feathers Hotel—I still remember its poor food and uncomfortable bed!

I immediately started work on Field Marshal V; thirteen years before, I had done Field Marshal II, King Edward VII's charger.

The Champion on which I was beginning work, was one of the finest specimens of that breed, standing eighteen hands high and broad in proportion. He was a bay with black points and shaggy feathers—

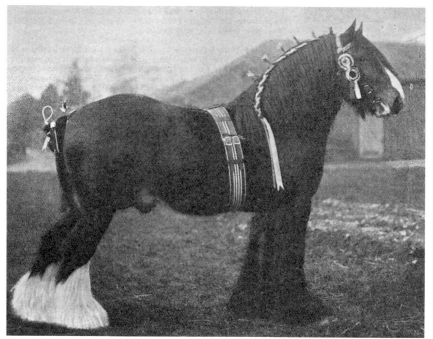

Shire Stallion, Field Marshal V

the hair which grows downwards from the back of the knees and hocks was partly black and partly white; his massive hoofs were almost entirely covered by this long straight hair; his tail was docked, and when presented at shows his mane and tail were braided and beribboned; his nose was white.

Being accustomed to making models of much lighter horses, I found that at the beginning, I was unconsciously making *Field Marshal V* hardly heavier than the average weight-carrying hunter. One of the characteristics of a fine Shire horse is his immense weight, weight that a team puts into a plough, or a heavily loaded cart, or against a piece of artillery. I am referring, of course, to heavy artillery used in World War I. In the Middle Ages, they may have been used to carry Knights fully armed. I readjusted my vision, and also the amount of plasticine required, and after two weeks' work brought back my model to London, and added it to my Exhibition before it closed. . . .

Harboro' Nulli Secundus

Harboro' Nulli Secundus was, like Field Marshal V, of gigantic size, measuring eighteen hands. He had a beautiful sloping shoulder—more the shoulder of a blood horse than a draught horse— powerful rounded quarters, a well developed foreleg, a fine expressive head carried proudly high, a scornful eye, and a high action when trotting, remindful of a hackney; this, of course, was very exceptional in a horse of his breed [see p. 5]. He was bad-tempered, suspicious of a stranger, and apt to hit at you with his forelegs when you were least expecting it. He wore a bluff, or bandage over his eyes, as he was considered to be less dangerous when he could not see. I was warned by the stud-groom not to pat him and, in fact, to keep away from him as far as possible. I was also asked not to talk, as this might irritate him so much as to make him entirely unmanageable.

When the time arrived for doing the eyes, which were completely hidden by the bluff, I put the problem up to the farm manager and stud-groom, explaining that it was imperative for me to see his eyes, if only for a few moments. As they both wished to help me in every way, Harboro' was led out into the middle of the paddock and held by four men by means of chains tied to his bridle. I quickly put my modelling stand in place with my model on it [see p. 5], and all my tools ready— all in complete silence so as not to irritate the Champion. When all was ready, the bluff was removed from his eyes and I went to work without

Shire Stallion:
Harboro' Nulli Secundus

Bronze, gold plate
29 ½ x 11 ½ x 28 inches
(74.9 x 29.2 x 71.1 cm)
AFTER 1922
VIRGINIA MUSEUM OF FINE ARTS,
THE PAUL MELLON COLLECTION, 86.132

SIRE: *Babingley Nulli Secundus.*
DAM: *Tatton Frieze by Tatton Friar.*
Foaled 1914. Bred by W. T. Hayr and owned by Mrs. Stanton, Snelston Hall, Derbyshire. First and Reserve Junior Champion at the Show of the Shire Horse Society, 1917. First and Reserve Champion at the Show of the Horse Society, 1918. First and Champion at the Show of the Shire Horse Society, 1922 and 1923. First and Champion at the Show of the Royal Lancashire Society, 1923.

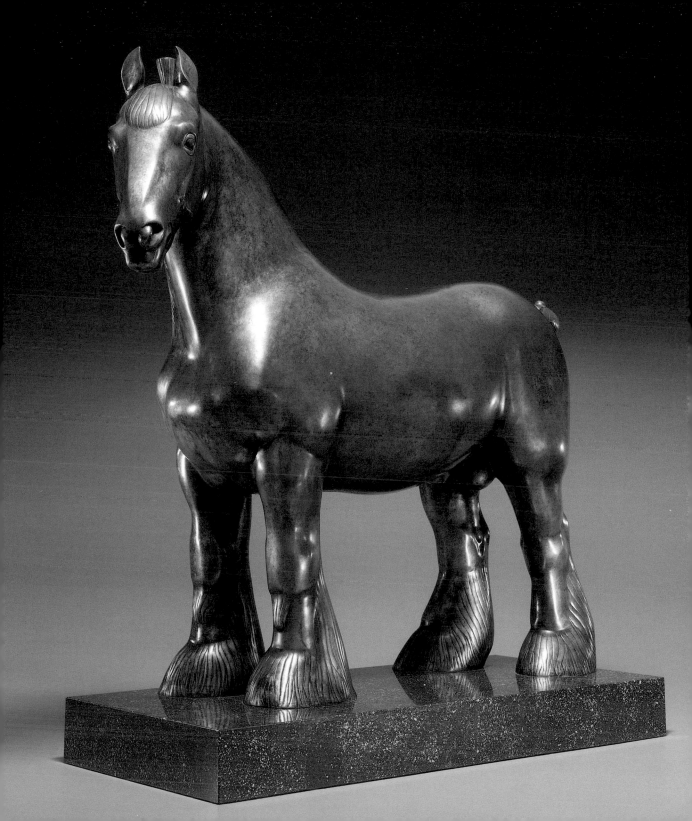

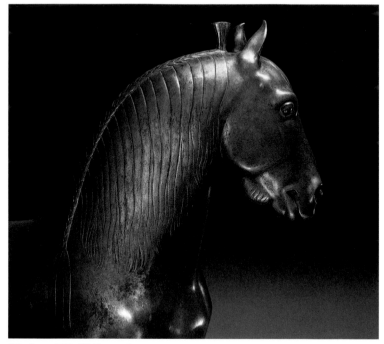

Harboro' Nulli Secundus

losing a minute. At first he looked surprised at seeing me. "So this is the worm I've felt hovering about me!" he seemed to be saying to himself. Then, an expression of utter scorn seemed to come into his eyes, as he contemptuously surveyed me with lowered lids—"*de haut en bas,*" as the French would describe it. His surprise seemed so great that he remained quite still for at least five minutes, then he started pawing the ground, swishing his well-combed feathers in every direction and tearing up great tufts of grass with his feet.

With regard to his love life, Harboro' was by inclination strictly a monogamist, although, owing to his being a Champion, the best Shire brood-mares were sent to him from all over the country; his fancy was focused on . . . one old mare on Mrs. Stanton's Snelton Hall estate, and he viewed matrimonial alliances with expensive concubines with indifference and disdain. Highly paid services were booked months and

even years ahead, and a way had to be found to meet these obligations. I assisted at some of these operations, when the greatest ingenuity was called for . . . in order to obtain results. His eyes were covered with a bluff, . . . but his sense of smell proving to be specially acute through his being deprived of his sight, the legitimate wife, the old mare, dear to Harboro's heart, was first led up to her lover, who immediately showed interest, whereupon old Matilda was led away and the expensive and expectant concubine put in her place and the marriage consummated.

After the battle, Harboro' would be led back to his stall by the groom, who, as soon as he unhooked the leading-strap, would skip nimbly out of the stall, as Harboro' would make a rush at him with bared teeth and the intention of biting him and striking him with his forefeet.

A few years after my visit to Snelston Hall, Harboro' died suddenly from what appeared to be a stroke. He was buried under a venerable oak tree on the estate.

In the summer of 1942, while visiting the Pomona Agricultural Show, in California, I saw among a group of Shire horses one that seemed strangely familiar—a bright bay with black points and plenty of white on the feathers. When examining his pedigree, I found that he was a descendant from the great Harboro' Nulli Secundus!

I evolved a system of work by which the moment I felt I was becoming stale while doing one particular subject, I would take the train to the place where another animal lived, and begin or resume work on that one. . . .

The summer and early autumn months when the weather was more favourable, I mostly spent in England on my outdoor work, and during the winter months I continued the work in Paris in my studio. In 1922, however, I stayed as late as December in England, modelling the statue of Sudbourne Premier, the Champion Suffolk Punch.

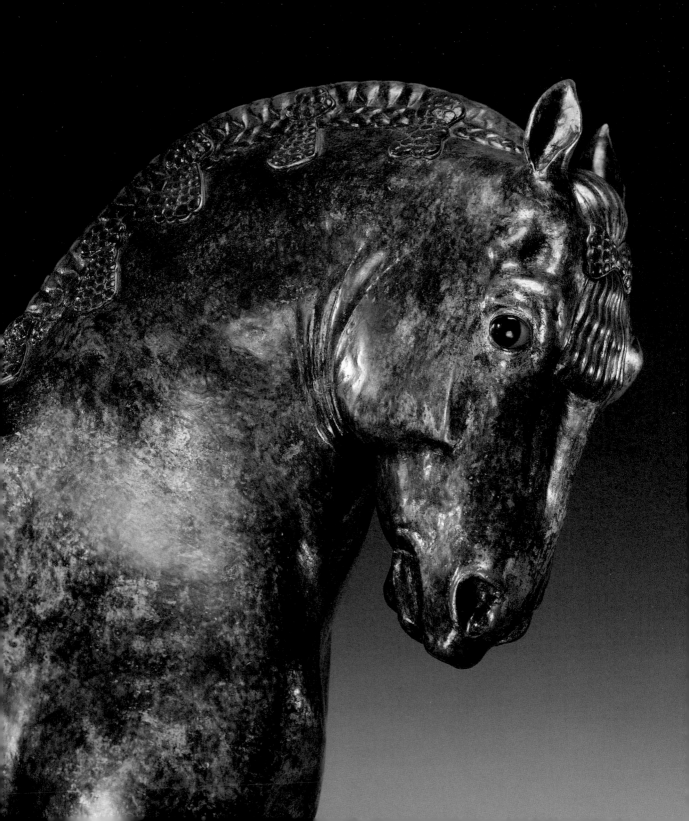

SUFFOLK PUNCH STALLION

Sudbourne Premier

Suffolk Punch Stallion:
Sudbourne Premier

Bronze, gold plate, lapis lazuli,
ivory, onyx
21 ½ x 24 ½ x 6 ½ inches
(54.6 x 62.2 x 16.5 cm)
AFTER 1922
VIRGINIA MUSEUM OF FINE ARTS,
THE PAUL MELLON COLLECTION, 86.133

SIRE: *Sudbourne Beau Brocade.*
DAM: *Sudbourne Moonlight.*
*Foaled 1919. Bred by Lord Manton
and owned, after July 11, 1923, by
Percy C. Vestey, Easton Park, Wickham
Market. First and Champion at the
Show of the Royal Agricultural Society
of England, 1921 and 1922. First and
Champion at the Suffolk Show, 1922
and 1924. First and Champion at the
Woodbridge Show, 1923. First at the
Derby Show 1923, among others.*

The moment I saw Sudbourne Premier, the magnificent stallion of that famous breed of chestnuts, all my troubles were forgotten and my only thought was to get to work.

The groom was holding him for me and I had to set up my modelling stand and spread out my tools, having measured his height (sixteen hands one, I think), when the red-headed clerk came pedalling up on his bicycle and, seeing what was going on, said it would never do to have the horse standing in the cold and I would have to work in the stall, which incidentally was almost pitch dark.

"If the horse is to stay outside, he is to be kept walking," he said with a supercilious air, probably thinking . . . : "Now you're stumped, my boy!"

"By all means, have him walked around," I agreed cheerfully. "I think I would prefer him to be walking rather than standing still."

So I placed my stand in the middle of an open space and had him walked round and round, first one way, then the other. Sudbourne Premier was at his best: he stretched his neck and champed his bit, looking intelligently to right and left, showing a little of the whites of his eyes, which gave more life and expression to his already expressive and classical head.

The groom, who was very obliging, braided his mane and tail for me, as it was customary to do when he was being shown: this displayed

23

the line of his crest to the best advantage and lent itself to that stylized interpretation to be seen in my finished bronzes, which, subsequently, found their way to the Luxembourg Museum, Paris, the Tate Gallery, the Field Museum, the Palace of the Legion of Honour in San Francisco, and the Philadelphia Museum of Art.

I also had a few bronze heads of the same subjects, each one treated a little differently from the others, in surface and patina—for instance, the one in the Field Museum in Chicago [now in the Virginia Museum of Fine Arts, Paul Mellon Collection] was cast by the *cire perdue* [lost wax] process and has a reddish brown patina over a mercury gilt surface; the ribbons of the tail are of Persian lapis lazuli executed by Cartier in Paris, and the eyes are onyx and ivory; the bronze head stands on a rectangular Belgian granite pedestal without mouldings.

The one in the Luxembourg Museum in Paris . . . is cast by the sand-process, and is highly chased with mane, tail and hoofs heavily gilded, thus contrasting with the silver ribbons of mane and tail; it has a light-blue-green antique patina all over the surface and is mounted on a pedestal of travertine and stone.

The one in the Tate Gallery in London is also cast in bronze by [the] sand . . . process, is highly chased, [and] has a dark-green patina, gold mane, tail and hoofs, and silver ribbons. It stands on a dark-green Swedish granite pedestal.

The one in San Francisco, cast and chased in the same way, has a mercury gilding all over a reddish patina, lapis lazuli ribbons on forelock and braided tail, is mounted on a black Belgian marble base, and stands on a vase designed by the eminent architect Welles Bosworth, and placed on a pedestal of unstained French pearwood.

One of the smaller bronzes of this subject was bought by George Widener and donated to the Philadelphia Museum of Art; it had a

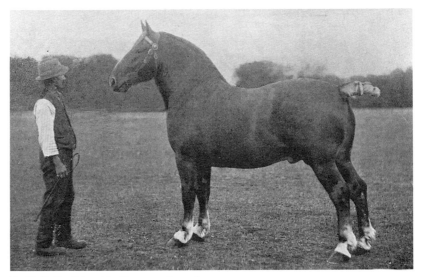

Suffolk Stallion, Sudbourne Premier

gold patina; I donated a small bronze of this subject to the Art Gallery of Eton College, where my son Marshall was then at school. John Blount, the drawing master of Eton, told me in June 1950 that it stands today in a prominent position in the drawing school and that it has been copied by several generations of Eton College boys, being a favourite subject for them.

To return to the living Suffolk Punch; the clerk who evidently had tried to put me off from modelling Sudbourne Premier, was obviously surprised that I welcomed the suggestion of making a model of him while he was in movement. Several times a day he would bicycle from his office to make sure that the horse was not getting "nervous."

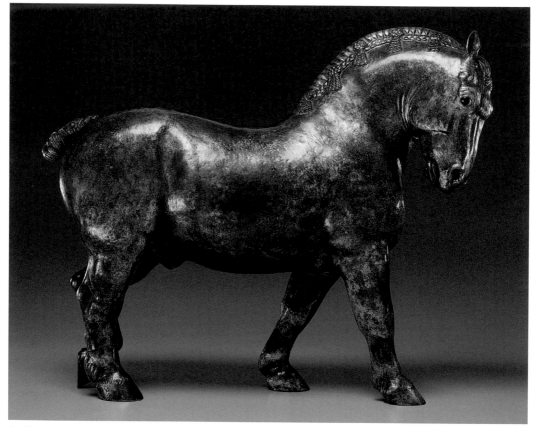

Sudbourne Premier

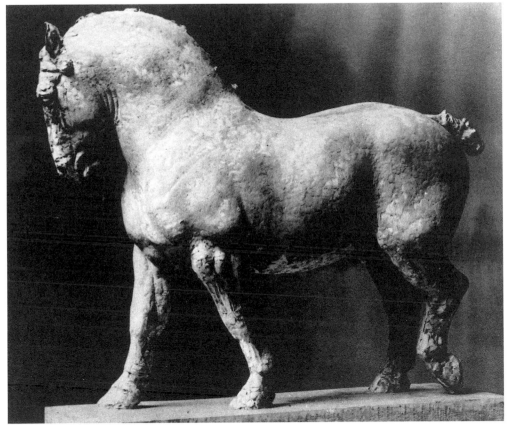

Haseltine's plasticine model of Sudbourne Premier

"How about me," I asked, ". . . in this freezing December weather?"

So as not to lose any time, I used to bring my lunch with me; when I asked if I could eat it in the saddleroom, where a small coal fire was burning, I was told by my friend that this could not be permitted. Maybe he thought I might steal one of the bridles! So I consumed my sandwiches and beer in the bitter cold. An old farmer suggested that I pour some whisky into my beer: "That'll warm ye!"

Annoyed by all these stupidities, I worked from early morn until nightfall, so that in five days I had accomplished sufficient work to allow me to take the model back to London.

Of the group of British Champion Animals, *Sudbourne Premier* was one of three models which I did "in movement," the other two being the *Middle White* and the *Berkshire Boar*.

Had I modelled the famous stallion standing still it would probably have been sleepy-looking and would not have had the characteristics which made it outstandingly different from the other models. So, thank you, employees of Easton Hall for not having been cooperative!

Quite a different atmosphere prevailed at the hotel to which I went The plump wife of the inn-keeper looked after me like a mother. She was an excellent cook and gave me the food which I had dreamed of Her husband had fought in the 1914–18 war and had picked up a certain amount of French; somehow or other having got it into his head that since I lived in Paris, I must be a Frenchman, he insisted on speaking French with me, obviously to impress his wife. I entered into the arrangement and we had long halting conversations in broken French, his wife no doubt being duly impressed.

Two days after I started work, I heard that the Agent had returned, but he gave no sign as far as I was concerned. At the end of five days of intensive work during extreme freezing weather, I decided that I had

done enough to warrant my taking the statue back to London; so I asked if I could have the lorry on the following morning to take me to the station. About two hours before my departure, I went to the stables to pack my model; just as I had nearly finished, the Agent, whose name I have forgotten, drove up in his car; after giving me what looked like a careful once-over, he mumbled some excuse for not having put in an appearance before, and expressed the hope that I would return to do some of the Red Poll Cattle on the estate. I am afraid I was not very enthusiastic about his suggestion and after a few banal remarks, I left for the station.

Charlie Carstairs, a cousin and head of Knoedler's Gallery, as usual the soul of kindness, allowed me to store my various models on the top floor of Knoedler's Gallery, where Captain (now Sir) Bruce Ingram, editor of *The Illustrated London News*, saw them and insisted on having them photographed and published; this was done in the issue February 28th, 1925, covering the two middle pages, and the front page on which was reproduced the plaster head of the Suffolk Punch. Also included were the first rough models of the Suffolk Punch, Sudbourne Premier; the Percheron stallion, Rhum; the Percheron group mare and foal; the famous chaser Sergeant Murphy, winner of the Grand National of 1923; and the Shire stallion, Harboro' Nulli Secundus. [Except for the photograph of the plaster head of Suffolk Punch, all of the photgraphs that appeared in *The Illustrated London News* are reproduced in this catalogue; see pp. 4, 5, 27, 30, 34 and 39.]

THE CHASER

Sergeant Murphy

Haseltine included Sergeant Murphy among the British Champion Animals (see previous page), but he does not discuss this horse in his memoirs.

The Grand National, won by Sergeant Murphy in 1923, is a particularly gruelling steeplechase. Instituted in 1839, it extends over more than four miles and has thirty-one, often hazardous, jumps.

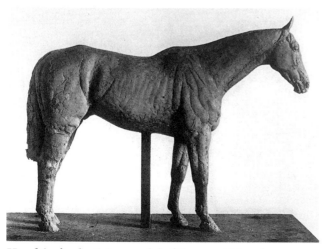

Haseltine's plasticine model of Sergeant Murphy

The Chaser: *Sergeant Murphy*

Bronze
23 X 9 X 27 INCHES
(58.4 X 22.9 X 68.6 CM)
SIGNED AND DATED:
HASELTINE/MCMXXVI
VIRGINIA MUSEUM OF FINE ARTS,
THE PAUL MELLON COLLECTION, 86.137

Chestnut gelding. SIRE: General Symons. DAM: Rose Graft by Ascetic by Rose Stock by Preston Pans by Roseleaf by Fright. Foaled 1910. Bred by G. L. Walker, Athboy, County Meath, Ireland, and owned by S. Danford.

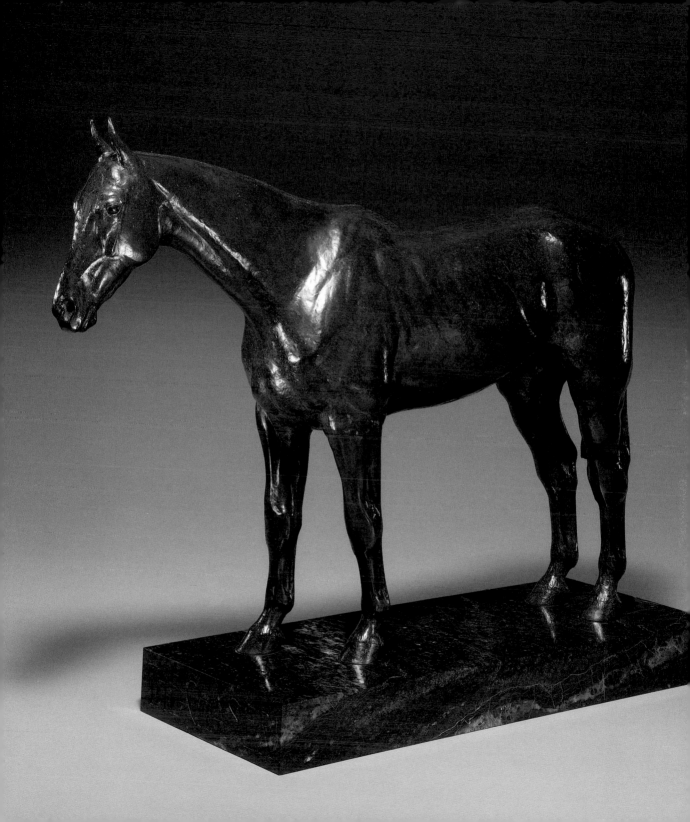

PERCHERON STALLION

Rhum

Besides the Shires and the Suffolk Punch there were the Percherons, the first models of which I modelled at Greyling Stud, Moreton Morrell, Warwickshire. They were the property of Mrs. Robert Emmet, an American by birth, who, after many years' residence in England, had taken up British nationality; her husband, also an American by birth, had fought in the B. E. F. [British Expeditionary Force] during the 1914–18 war, and had become a British subject like his wife.

The Emmets had a beautiful house, comfortably furnished, with a bathroom in every bedroom! The cuisine was delicious and every effort was made by hosts and staff to make the stay of their guests as agreeable as possible. . . .

[Rhum] was a grand specimen of Percherons—dappled grey, heavy of bone with powerful quarters, spirited head, a large expressive eye and delicately shaped ears. He showed the characteristics of his remote ancestor the Arab, who in the fifteenth century was imported into that part of France known as La Perche, now the breeding centre of the Percheron [see p. 4].

The British, appreciating the many fine points which they had noted in the specimens of the breed during the world war, imported a certain number of stallions and mares into England and incorporated the breed into those of British cart-horses; only greys were allowed to

Percheron Stallion: *Rhum*

Bardiglio marble
29 x 11 x 26 ½ inches
(73.7 x 27.9 x 67.3 cm)
Signed and dated:
HASELTINE/MCMXXX
Virginia Museum of Fine Arts,
The Paul Mellon Collection, 86.134

sire: *Lagor.* dam: *Mazurka. Foaled 1917. Bred by M. Chopin, La Bigottière, Bellème, Mortagne, France, and owned by Mrs. Robert Emmet, the Greyling Stud, Moreton Morrell, Warwickshire, England. First at Mortagne, 1919. First and Champion at the Show of the Royal Agricultural Society of England, 1921, 1922, and 1923. First and Champion, Norwich Stallion Show, 1922 and 1923.*

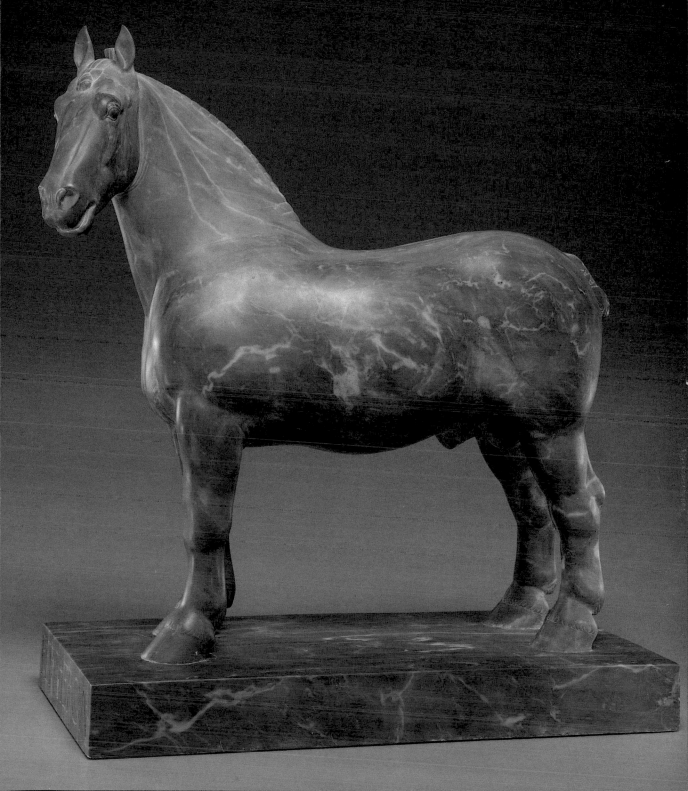

be presented at the Royal Agricultural Society's Shows. In France Percherons of other colours were occasionally to be seen, though greys, of course, were the predominant colour.

In the old days in Paris, the buses were drawn by Percherons. At an earlier date, they also drew travelling and mail coaches, and during the world war were extensively used in the French field artillery.

In my model, I represented the magnificent Rhum with head erect and turned slightly to the left, with eyes accompanying this movement. His lips were beginning to quiver, preparatory to neighing, as he would do when he heard the mares being turned out in the nearby pastures [see also p. 4].

Although of a fiery and high-spirited temperament, he was gentle and well-mannered, a vivid contrast to Harboro' Nulli Secundus. I could take measurements of his legs and trace the outline of his hoofs on a piece of cardboard with perfect confidence.

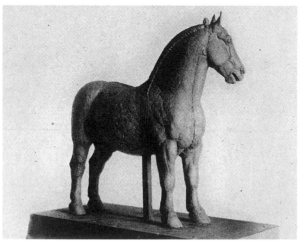

Haseltine's plasticine model of Rhum

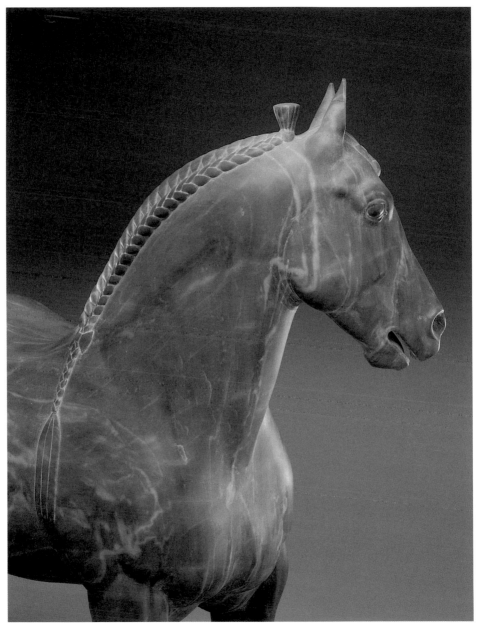

Rhum

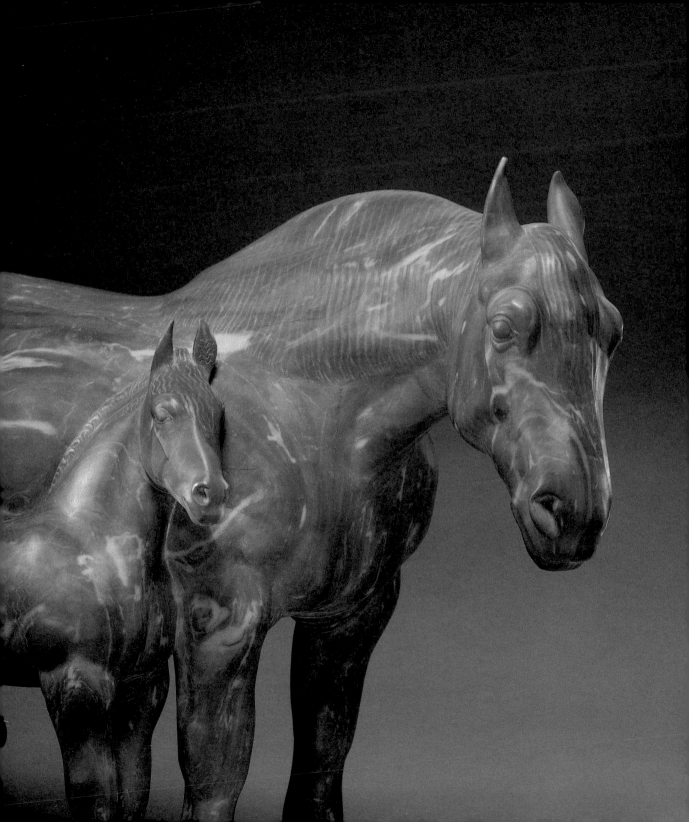

Messaline and Her Foal

Percheron Mare:
Messaline and Her Foal

Bardiglio marble
22 ¼ x 12 x 29 ¼ INCHES
(56.5 x 30.5 x 74.3 CM)
SIGNED AND DATED:
HASELTINE/MCMXXX
VIRGINIA MUSEUM OF FINE ARTS,
THE PAUL MELLON COLLECTION, 93.92

SIRE: *Douvreur-ex-Couvreur.*
DAM: *Paquerette. Foal date unknown.
Bred in France and owned by
Madame Robert Emmet, the Greyling
Stud, Moreton Morrell, Warwickshire.
First at Mortagne, France, in 1917, 1918,
and 1919. First and First in Class at
the Norfolk Society of Agriculture,
1920. First at the Show of the Royal
Agricultural Society of England, 1920.
First and Champion at the Show
of the Royal Agricultural Society
of England, 1921 and 1922.*

As an accompanying piece to *Rhum*, I made a group of Messaline, the Champion Percheron mare, with her foal by Rhum.

In strong contrast to the fiery and haughty Rhum, always on his toes, was the relaxed and patient-looking brood mare, whose sole preoccupation seemed to be caring for her offspring. The latter, almost black, was silhouetted against the grey colour, fast turning white, of his dam.

The foal was the most difficult to model; he was always hiding behind his mother, and even when held by an obliging groom, was never still for one instant. I worked very quickly, however, and managed to convey the spirit of startled effrontery mingled with fear, as he pressed himself against the spacious flank of his protectress. I thought I could see in the tilt of his head and the rolling of his eyes, a distinct resemblance to his sire.

I enjoyed doing this family group and in my first exhibition of the British Champion Animals at the Galerie Georges Petit, Paris, in 1925, I represented them in a group of three, cast in plaster of Paris and covered with silver leaf. This grouping, however, did not compose itself satisfactorily from different points of view, so I decided to separate them, *Rhum* alone, and *Messaline and Foal* forming a group by themselves.

From the original impressions in plasticine, made at the Greyling Stud and safely transported to my studio in Paris, I made plaster casts,

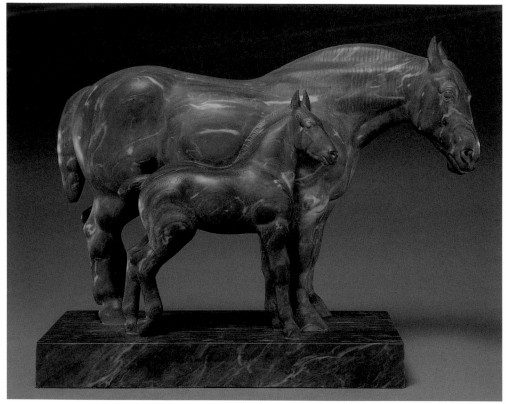

Messaline and Her Foal

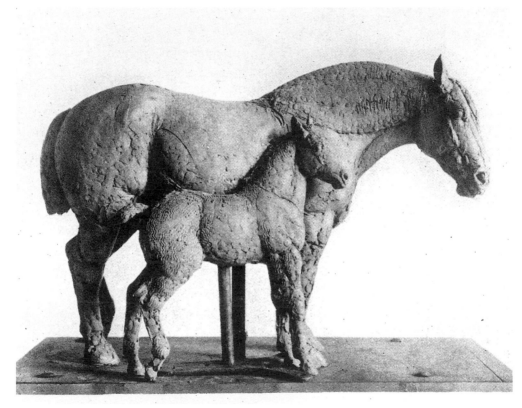

Haseltine's plasticine model of Messaline and Foal

and from these squeezed moulds in plasticine, on which I worked, simplifying here and going into more detail there.

Rhum's mane and tail were braided, and this lent itself to a stylistic interpretation of the subject; the braiding differed from the coiffure of the Shire horses, when attired for the show ring.

Before the Exhibition at the Galerie Georges Petit was opened, Mr. and Mrs. George Blumenthal came to my studio and gave me an order for the Percherons, i.e., sire, dam and foal, for the Metropolitan Museum, New York. These I ordered to be done by Rudier cast in bronze by the sand process, with a dark green patina; Cartier in Paris executed the eyes and ornamentations, i.e., eyes in onyx and ivory, ribbons in mane and tail, in coral. . . .

Another set of the same group was purchased and given to the Phillips Academy Art Museum, Andover, Massachusetts. This set was cast by Valsuani by the *cire perdue* process and beautifully patinated by him over the mercury gilding. The onyx and ivory eyes and the lapis lazuli ribbons in *Rhum*'s mane and tail were made by Cartier. *Rhum* and the *Mare and Foal* were finished in gold with punctuations in black, white, and blue; [and] were mounted on black Belgian marble bases, with their names and pedigrees carved on them. The lettering was designed by a Roman artist, Stanislau de Witten. Stanislau was a great friend of mine and I valued his friendship more and more with the passing of time, because he was one of those rare people whom one can justly describe as a saint.

I also carved this group in a cream-coloured Burgundy stone, and when Orpen offered to paint my portrait in the spring of 1925, I asked him to pick out one of my works in my studio. He chose *Messaline and Foal*. In later years I saw it, admirably placed in the middle of the entrance hall which led to his studio in Chelsea.

After Orpen's death, all his pictures and belongings were sold, and Mrs. Murray Danforth bought the group for the School of Design in Providence, Rhode Island, of which she was the President. She later bought the companion piece, *Rhum*, for the same Museum.

For the Field Museum, Chicago, and as part of the British Champion Animals, I made the same subject in grey Bardiglio marble, a streaky grey marble, somewhat recalling the grey of the horses' coats [now in the Virginia Museum of Fine Arts, Paul Mellon Collection].

A few smaller reproductions of the Percherons were also made in bronze; the last one of these, very stylized in silver and gold, was acquired in 1940 by Marshall Field for his private collection.

I also made this group in the same size for Bernon Prentice, as well as the *Percheron Mare and Foal* and two similar bronzes for Clarence Dillon.

I visited the Emmets again to do more work on the Percherons; later Mrs. Emmet gave me an order for the *Rhum* and *Messaline with Foal* group; these were cast by the sand process by Rudier with a green patina and similar ornamentations like the previous bronzes.

I also made a head of Rhum, from a plaster [cast] made from my first impression of this famous Percheron. The head was later cast in bronze and patinated by Valsuani—the patina being green with splashes of gold. It was purchased in 1940 by Mr. Grenville Winthrop and included in his magnificent collection of works of art from all over the world covering many periods. After his death, this collection went to the Fogg Art Museum at Harvard University.

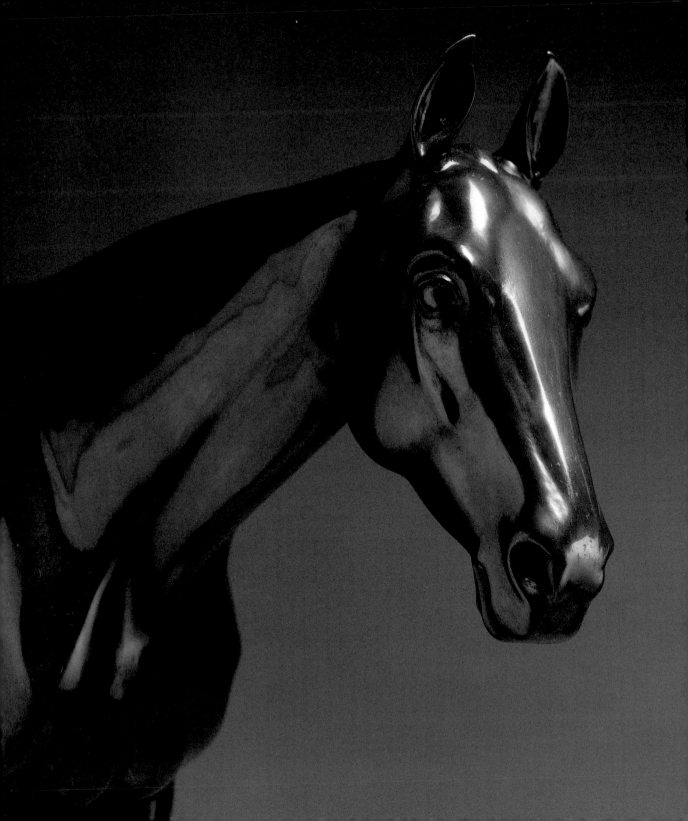

POLO PONY

Perfection

Just before I made my first model of Harboro' Nulli Secundus in the summer of 1922, I had begun one of Major Jack Harrison's Perfection, a bay Irish polo pony, fifteen hands two high, with a docked tail and the look of a miniature hunter. He could not have been more appropriately named. He had quality, bone and substance, besides speed and great ability on the polo field, and had won a number of prizes at shows.

It was a great pleasure and stimulus to make this model. I began it at Jack Harrison's stables in Putney during a spell of rainy weather, which necessitated my working in the damp and brought on an acute attack of lumbago, the foundation of which had been laid during the war.

I think it was the autumn of the following year when I resumed work on *Perfection*, this time staying with the Harrisons at their delightful country place, King's Walden Bury at Hitchin. They had seven young daughters, and two more were added in the following years.

Besides having a very fine string of polo ponies, Jack Harrison had a stable full of some of the best weight-carrying hunters I have ever seen. His charming wife, Marjorie, also hunted, and so did all the little girls as soon as they could walk and sit on a pony.

All the hunters and polo ponies were beautifully trained and looked after, and it was a pleasure to visit the stables, with every horse in his

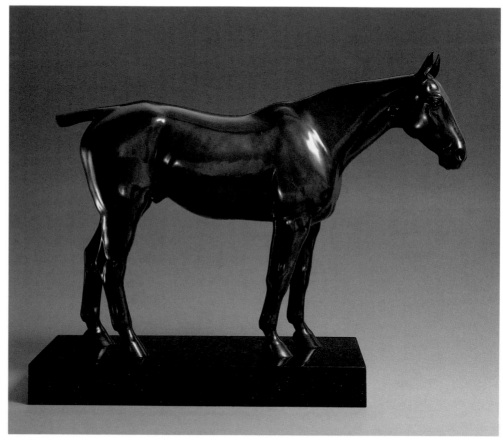

Perfection

box filled with clean fresh straw, brasses polished, leather well soaped and cleaned, brow-bands of head-stalls impeccably pipe-clayed, tails bandaged—every detail carried out to perfection! There were rows and rows of saddles and bridles with their polished steel bits and bridoons [snaffle and reins], hanging up in the spacious saddleroom.

The house was comfortable, the food excellent, the port wine such as you can only get in England!

I visited the Harrisons many times afterwards, and even if I had not seen them for months, always it was as though I had seen them the day before! The girls are grown up now, several married. I last spent an afternoon with them in July or August 1939, while I was staying with the late Mrs. Clayton at Severals and making a model of Bois Roussel, winner of the Derby, for the late Hon. Peter Beatty.

COMPOSITE TYPE

The Thoroughbred Horse

T *he Thoroughbred Horse,* Composite Type, was added to the collection of British Champion Animals.

This model was begun as far back as 1912 and exhibited in patinated plaster at the Salon des Artistes français. It measures two metres at the withers—approximately twenty hands high.

Aimé Morot urged me to make a model on this scale, declaring in the kindness of his heart that it would definitely place me before the public and probably get me many orders. The problem was to find a beautiful and perfect model from which I could get my inspiration, but search as I would I could find no animal, either in my memory or actually alive, that came up to the ideal. One toed out, another in, this head was too common, that one possessed cow hocks, another horse's cannonbones were too tight under the knees, some bodies were too short, others too long—and so on, until I realized that my quest was doomed to failure.

Then I hit upon the idea of taking the good points and details of individual horses, recalling those I had already modelled in the past and combining them with living models; in this way I would be able to approach the ideal I had in mind. . . .

With the idea of finding a thoroughbred horse which would fit into my ideal, if only partially, I used to haunt the sales at Cheri's and

Composite Type:
The Thoroughbred Horse

Bronze
22 x 9 x 27 inches
(55.9 x 22.9 x 68.6 cm)
Signed and dated:
HASELTINE/MCMXXV
Virginia Museum of Fine Arts,
The Paul Mellon Collection, 86.135

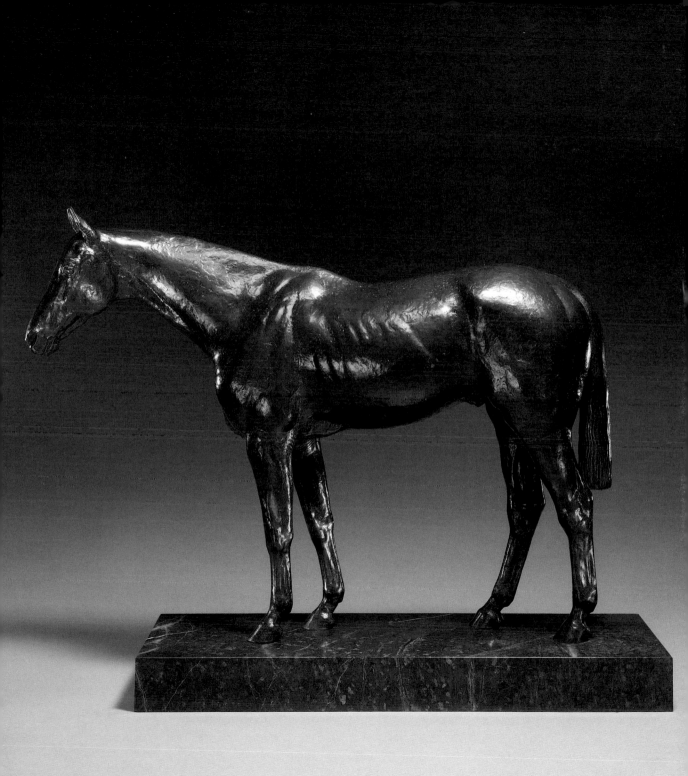

Tattersall's, without finding what I really wanted. Suddenly one evening at Tattersall's I looked into a box-stall and saw a sleek, black thorough-bred, every inch a race horse, with a head that was the essence of quality, large lustrous eyes, tapering nozzle, deep jaw, small sharply stencilled ears, a head reminiscent of, in fact very similar to his Arab ancestor, and to the highly bred horses painted by Alfred de Dreux.

The rest of his conformation was generally good, but it was his beautiful, keen head and expression that took my eye and made me fall in love with him. He was well-bred, being a son of Simonian by St. Simon, both great sires in their day.

My dear mother bought him for me. The owner, a Monsieur Ullmann, said he would like to have a sketch of the horse, in addition to the amount paid for him. I was so delighted to own Noel II, that I made a bronze of him, with mane and tail banged, and much to M. Ullmann's surprise, presented it to him as my part of the bargain. . . .

But to return to my Composite Type. When I started analyzing Stally [Noel II] . . . , I realized that apart from his beautiful head and the rhythm of his movements, there were decided flaws in his conforma-tion. I began to look about for a more perfect model and heard that Joe Duveen's brother, who owned race horses, had given a good-looking chestnut to Charles Romer Williams, one of the partners in the firm of Thomas Agnew & Sons, . . . who was in charge of their Paris branch.

I went to see his horse, a three-year-old and full brother to the out-standing Pretty Polly. He was a bright chestnut with plenty of bone and of beautiful conformation, just what I had been looking for, everything except head and neck, the former being coarse and heavy with lop ears and attached to a short, thick neck, but his legs were perfect, "One in each corner" as Peter Gilpin used to say. He had a fine, sloping shoul-der, good, powerful quarters, perfect hocks, pasterns and feet.

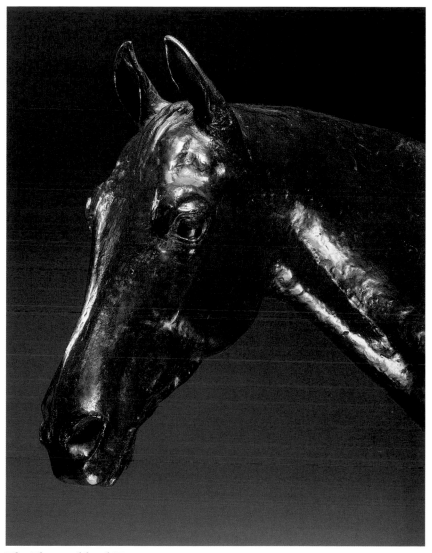

The Thoroughbred Horse

With this body and Stally's head and neck, I was getting nearer to what I wanted and had enough to get on with.

My studio at 4, rue du Docteur Blanche in Paris, being twenty metres long and ten wide, was large enough to enable me to set up my armature and an elevated platform, with a sloping approach for the horses to walk up to it and pose. I had an old coachman, Emile by name, who on alternate days used to hold Stally and the chestnut, whose name I have forgotten.

This was one of those periods of very intense work, when everything is forgotten except the accomplishment of one's object. Up early, on my feet all day and to bed betimes to get the necessary rest for the next day. As a matter of fact it is strenuous exercise climbing up a scaffolding, then down again to get a view of the ensemble, then hurrying back with it closely grasped in one's mind, with the fear of forgetting it before you reach your objective, namely the clay model! I had to take a great many measurements—measurements of the two horses that had to be scaled up to the heroic dimensions of my model, and this was an intense mental and bodily exercise.

On Sundays, I did not work, but I had a visit from my friend, H. A. V. Coles, an English photographer. He had been in France for over twenty years and hardly spoke a word of French.

Every Sunday morning Coles used to come to my studio with his camera and take eight photos of my model: front, back, the two sides, two three-quarter front views and two three-quarter back views. He would let me have the prints as soon as possible, each one mounted on a large cardboard sheet, allowing enough space for seven more to be added to the first; seven more, because I had seven more weeks to finish my *Thoroughbred* from the time I began taking the eight consecutive Sunday photographs. Each square of cardboard contained the

progressive stages of the same view, thus enabling me to see the progress I had made. This system was a great help.

The completed statue was cast in plaster and patinated a nondescript light brown. I exhibited in the Salon of 1913, with the bull-fight group *Un Payazo*, and received good criticisms both in the press and by horse lovers.

A sportsman friend of mine who often came to my studio has suggested that I should choose "complete repose" for the *Thoroughbred*, thus giving full value to all the fine points in this attempt to create the ideal thoroughbred, and avoiding the disturbed, flamboyant contortions so often seen in equestrian statues—"*tourmenté*" (tormented) as the French so aptly describe with their highly developed wit. Horses pawing the ground with an action as high as a hackney's, mane and tail flying in turbulent disorder, the rider standing in his stirrups and pulling at the horse's mouth, probably waving a sword and with mouth wide open, in order to convey the idea that he is shouting a command.

It is just as possible to put as much, or even more, motion or vitality into a horse standing perfectly tranquil, as in one in violent action; in the long run you get very weary of the latter and would give anything to see that arm lowered and that open mouth shut. . . .

I have already mentioned that I made this statue in its original heroic size, not beginning, that is to say, with a smaller model and then enlarging it later, as I have sometimes done in subsequent works. I afterwards had it reduced by Haligron *père*, that amazing expert artisan of reduction and augmentation. The reduction was about one-third life-size.

Two bronzes, cast by the *cire perdue* process, were made by Valsuani of the *Pur Sang*, as I called this model when shown in the

Salon. One was purchased by my friend Herbert Ward, the English sculptor, who was a clever draughtsman, besides being an excellent sculptor—dedicating his talent to statues of African negroes. . . .

Another similar model in bronze was bought by Howard Young, the New York picture dealer, who for a number of years in early summer used to drop in at my studio and buy a number of the bronzes. This one he sold to a Mr. Crispin Oglesby of Cleveland, Ohio, who was a great lover of fine horses. . . .

During the time that I was working on the British Champion Animals, I made another reduced model of the *Thoroughbred*, by Haligron *fils*, made at one quarter the size of a horse measuring sixteen hands two. I had remodelled it entirely, and changed Noel II's head, so that it did not look too small for the body, which I made from Bittersweet, a thoroughbred hunter.

Of this new and perfected model, I made one in bronze *cire perdue* of the same size, cast and beautifully patinated by the older Valsuani; this model was included in the collection of British Champion Animals. It was mounted on a very fine piece of Scotch serpentine marble, which harmonized to perfection with Valsuani's wonderful patina, made on a bronze in which silver was included in the alloy. Later I reduced this model to half-size and made a number of bronzes of it, which I frequently meet with in people's houses in the United States and in England.

When the Second World War broke out in 1939, I was at work on a further model of this subject, making certain necessary alterations. I lengthened the tail, making it stand out from the body, thus showing the silhouette of the quarters to better advantage. I also braided the mane in the latest fashion, in the horse coiffures in England and France—that is, braided and rolled so as to form a sort of ball.

The greatest compliment I had paid me in regard to the *Thoroughbred Horse* was by a horse-dealer who said: "No such faultless animal ever existed!"

This may sound conceited on my part, but I merely quote what he said, because personally, I could, and can still see only the faults; this is usually the case with all my works and a state of mind I find myself obsessed with, when hard at work on any special subject. In my experience, this is the only way to obtain results, because when, on very rare occasions, I have been somewhat pleased with my work, it has invariably resulted in being extra bad.

Another point: inspiration only comes with hard work; at least, that has been my personal experience. Ideas only come in the midst of great production and in a period of intense labour. Then ideas seem to arrive from all directions, and one hardly has time to make a note of them. When not actually at work, all inspiration ceases, because, I suppose, the mind is in a state of semi-atrophy. I have often been assured by well-meaning friends how perfectly they understand the artistic temperament. According to them, an artist cannot achieve anything until the Goddess of Inspiration grabs him by the hair, and drags him from his be-cushioned divan, and in the twinkling of an eye, dashes off a masterpiece! To all such rubbish there is only one answer: "Nuts!"

Lovers of horses have perhaps liked this last mentioned model the best. Of the one-eighth size bronzes which I made of it, I sold a limited edition of twelve, all cast by Valsuani the younger, by the *cire perdue* process with varying patinas and mounted on different kinds of marble bases.

I presented a model of the *Thoroughbred Horse* to Winston Churchill in 1949, which he placed in his study in Chartwell.

Polymelus

Polymelus, England's greatest thoroughbred stallion, had been Champion for the last three years. Sired by Cyllene, out of Maid Marian, he was foaled in 1902, and lived up to March 1925.

He himself was the winner of a dozen or more famous races. He was bred by the Marquis of Crewe and owned by Solly Joel, the rich South African diamond magnate. He was Champion Sire for five years, his progeny winning over a million, one hundred thousand dollars.

Polymelus was in his 24th year when I went to Reading to do him, and I was shocked at the sorry and dilapidated sight that met my eyes. He was nothing but skin and bones, well over at the knees, his hip-bones sticking out so far that you might have hung your hat on them; the voluptuous crest, a characteristic of the stallion's neck, was shrunk and caving, like the neck of an old man—what in horse parlance is usually called a "ewe-neck"—and very much so.

With all this, a vicious character, of which I was warned by the stud-groom.

I stopped at a simple but comfortable inn near a river and used to walk about two miles to the Joel residence, situated in a large park. One passed the house and walked on to the stud-farm. So as not to waste time, I brought my lunch with me and as it was summertime, would sit down in the shade of a tree and eat my frugal meal there.

Thoroughbred Horse: *Polymelus*

Bronze
23 x 9 x 26 inches
(58.4 x 22.9 x 66 cm)
Signed and dated:
HASELTINE/MCMXXVIII
Virginia Museum of Fine Arts,
The Paul Mellon Collection, 86.136

sire: *Cyllene.* dam: *Maid Marian. Foaled 1902. Died March 1925. Bred by the Marquis of Crewe and owned by S. B. Joel. Champion sire for five years. Winner of Richmond Stakes, Goodwood; the Rous Memorial Stakes, Newmarket; the Criterion Stakes, the Fifty-second Triennial Stakes, Ascot, among others. Successful progeny included winners of the St. Leger, the Two Thousand Guineas, the One Thousand Guineas, the Oaks, and many others.*

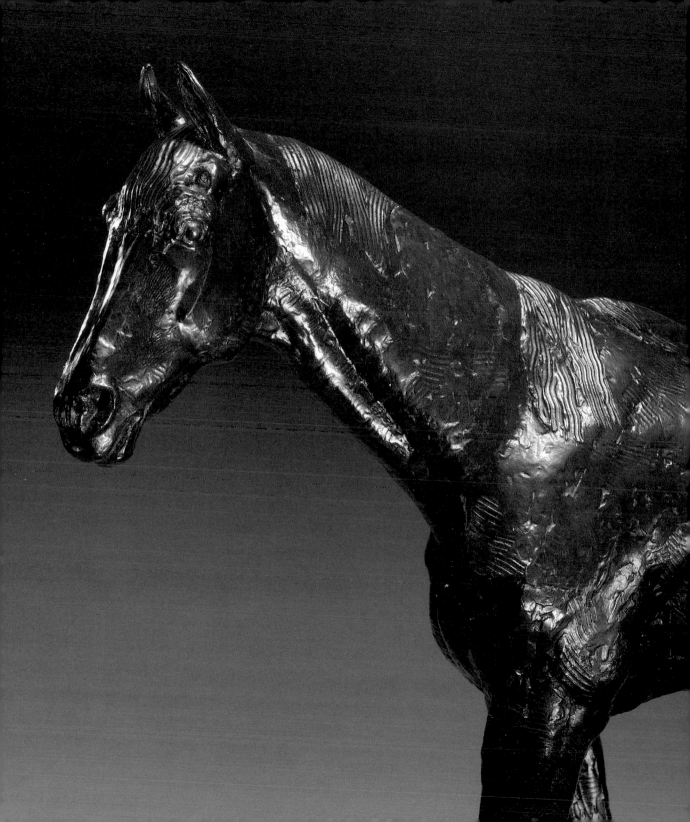

After the second day, I was told by the very obliging stud-groom that it would be better if I came in and out of the tradesmen's entrance. Apologizing for my faux pas, I scrupulously adhered to his instructions for the rest of my stay! It had been suggested that I should do Polymelus as he had looked some fifteen or twenty years before, but I found the old horse so interesting as he was, so different from all the other Champions, that I decided to model him exactly as I saw him. He reminded me so much of the old bull-fight horses I had modelled in Spain, and however sorry I felt for him, he did not crave sympathy; decrepit as he was, he never lost an opportunity of baring his old teeth or trying to kick anyone who came too near him. In spite of the ravages of old age, one was conscious of his fine build and of what he must have been in his younger days. His long rein, deep sloping shoulder and general bone structure, were characteristic of an animal of very high breeding.

One day when I was working in the box-stall with my back to the door, I heard a thick, rasping voice behind me saying "Poor old fellow, poor old fellow!" I thought it was someone referring to me, and turning round saw a sallow complexioned middle-aged man, with a drooping moustache, wearing a pongee suit, a sun helmet, black goggles, holding a green umbrella over his head—and astride a white Egyptian donkey held by two grooms.

"That's Mr. Joel," whispered the groom.

I was getting ready for the exchange of a few pleasant words, but all he said again was, "Poor old fellow, poor old fellow," still meaning Polymelus! Then he rode away and I never saw him again.

One day before I left, the stud-groom said, "Now that the master is away, I will take you up to the house, where you will see pictures such as you have never, never seen in your life before. Of course, I won't be

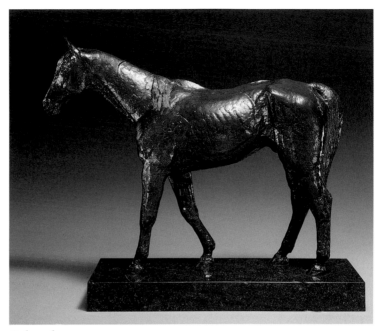
Polymelus

able to take you inside, but you'll be able to peek through the windows that give on the terrace."

So, led by my friend, I peeked through the windows and saw a bewildering conglomeration of pictures, in bright and heavily gilded carved gold frames, life-size statues of naked ladies in snow-white marble, elaborate gilt furniture, chairs covered with bright scarlet and crimson brocades, lace curtains at the windows, as well as bright blue and red plush ones, tables groaning with knickknacks.

The stud-groom had spoken the truth! Never had I seen a house the likes of this before! I expressed my gratitude to him and took my departure with the plasticine sketch of Polymelus.

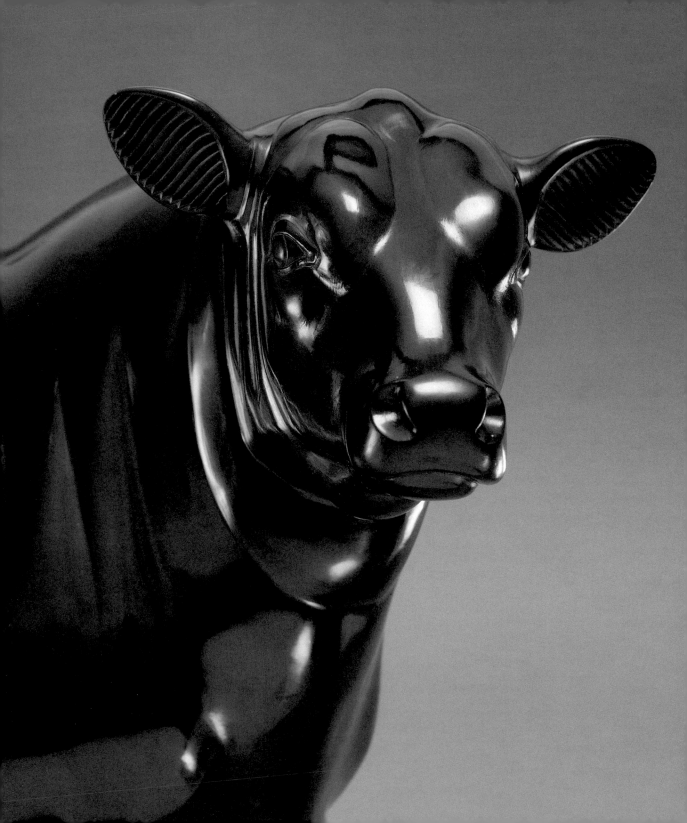

ABERDEEN ANGUS BULL:

Black Knight of Auchterarder

Aberdeen Angus Bull:
Black Knight of Auchterarder

Belgian marble
20 x 11 ½ x 27 inches
(50.8 x 29.2 x 68.6 cm)
Signed and dated:
HASELTINE/MCMXXXIII
Virginia Museum of Fine Arts,
The Paul Mellon Collection, 86.139

sire: *Evmar.* dam: *Blackbird V
of Braevail. Calved 1919. Bred by
A.T. Reid and owned by Sir Leonard
Brassey, M.P., Apethorpe Hall,
Peterborough, England. Champion
at the Show of the Highland and
Agricultural Society of Scotland,
1921 and 1922.*

The Champion Aberdeen Angus Bull was Black Night of Auchterarder. He was calved the 26th of April, 1919. . . .

Sir Theodore Cook had written to Sir Leonard Brassey about my doing the model and I had subsequently been in correspondence with him about the date when I should go up and begin work on the bull.

When I proposed a certain date, it was suggested that my arrival should be deferred until after the family had left Apethorpe Hall, a beautiful fifteenth-century country house, restored and beautifully furnished, combining great comfort with impeccable taste. The house was very large with spacious drawing-rooms, dining-rooms, breakfast-room, library and many bedrooms. I had a very comfortable suite, bedroom, sitting-room and bathroom, and my meals, which were excellent, were served on a tray in my sitting-room. An old family servant, Fred by name, used to bring them up to me; and as he seemed to know a certain amount about cooking, we used to discuss how the various dishes were made.

Up to then, I had only done Spanish fighting bulls; one of them, in particular, was a *Miura* bull, about whom I have already spoken and which was the first model in which I attempted a technique where the planes were essentially observed—a transition period from the old *pompier* stuff to something broader and more plastic.

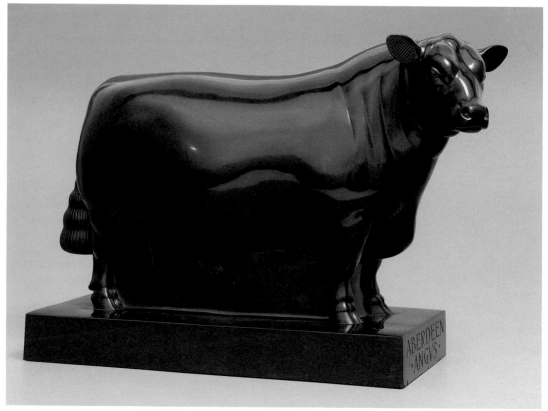

Black Knight of Auchterarder

Black Knight of Auchterarder, the outstanding Champion at the Royal Show for the last three years, stood before me black and shiny—as if already carved in black marble. His body, fattened to the maximum for the shows, stood out in contrast to the small, finely chiselled head, so characteristic of this finest of the breeds of poll cattle. His back was flat, the outline being unbrokenly horizontal. His quarters figured the baron of beef which, metaphorically speaking, simmered under the skin.

He was described by Georges Bénédite of the Académie française in the catalogue of my 1925 Paris Exhibition, and translated by Harry Melville for my London Exhibition of the same year as follows:

"The Aberdeen Angus, a Scottish breed, is black without horns. His strong, bony frame is on a small scale, but carries a heavy mass of flesh."

A few weeks later, having completely forgotten all the details of Black Knight, I returned to Apethorpe and resumed work on my model. At the back of my mind, I knew that he would be shown at his best if ultimately carved in black marble.

My days were greatly enlivened by the presence of two small girls, staying in the house with their governess; one was an adopted daughter of the Brasseys, the other, a young friend—both about six or seven years old. I used to have luncheon with them and they sometimes came to watch me at work.

I was getting on well with my work, when I heard that the Brasseys and a big house party were coming down for the weekend. Was I supposed to go away, like the house-painter or the plumber might be expected to do? I explained my predicament to Fred, who said that I was expected to remain. For over a period of many years I have been the recipient of genuine and friendly hospitality in the United Kingdom. There is, on the other hand, no country where I have at times been made to feel less at home than in England. Whether it is the

insular and inborn distaste for foreigners, combined with a natural shyness I do not know, but whatever the origin of this feeling may be, it is instantly communicated to the visitor who is not one of the usual crowd. I have often forced myself to make conversation, while submitting to the very obvious searchlight of the "once-over."

Everyone had arrived by tea-time, and I went into the drawing-room where—and this is also a typical English custom of the old school—I was introduced to no one, but obliged to join awkwardly in the conversation, making every now and then an obvious remark about the weather.

After a while, I escaped to my room and while I was sitting reading by the fire, and waiting for the time to dress for dinner, there was a knock at the door and Sir Leonard came in and said how sorry he was that neither he nor his wife had realised who I was. He had thought I was a friend of his children, which, of course, was very flattering, as they were so much younger than I! When I came down to dinner, the atmosphere was considerably clearer and the conversation flowed on a smooth plane.

I stayed on until the following Friday, and although invited to stay over the weekend, I preferred to take my departure, for when I was staying with new acquaintances while doing some animal, I made a point of never remaining one minute more than was necessary for my work, because I constantly heard about artists who stayed on and on, long after their work should have been finished, just to get free lodging and meals.

On the whole, I enjoyed my stay at Apethorpe. I carved the bull in black Belgian marble—one model for the collection of British Champion Animals, that ultimately went to the Field Museum in Chicago[now in the Virginia Museum of Fine Arts, Paul Mellon

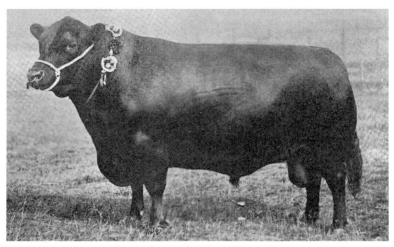

Aberdeen Angus Bull, Black Knight of Auchterarder

Collection], another for Marshall Field himself. A third model was purchased by the late Thomas Cochran and donated, together with the Percheron bronzes, to the Art Museum at the Phillips Academy at Andover, Mass.

I made two smaller ones, also in black marble, one for the late Douglas Fairbanks, and the other for John W. Garrett in Baltimore. I also made one or two small bronzes of this subject, one of them being bought by the first Mrs. Hamilton Rice, together with the bronze *The Shorthorn*, and given by her to her son George Widener, the Philadelphia sportsman.

So much for Black Knight of Auchterarder.

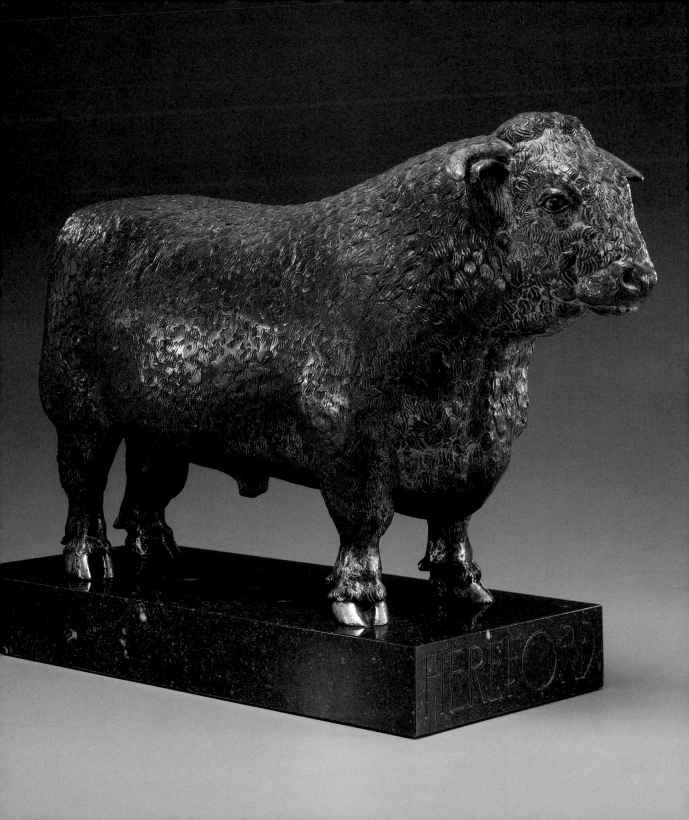

Twyford Fairy Boy

Hereford Bull:
Twyford Fairy Boy

Bronze, gold plate
19 x 10 x 27 INCHES
(48.3 x 25.4 x 68.6 CM)
SIGNED AND DATED:
HASELTINE/MCMXXVIII
VIRGINIA MUSEUM OF FINE ARTS,
THE PAUL MELLON COLLECTION, 86.141

SIRE: *Bounds Investment.*
DAM: *Fairy Girl III. Calved 1920.*
Bred and owned by Charles H. Tinsley,
Twyford, Pembridge, England. First and
Champion in 1922 at the shows of the
Royal Agricultural Society of England,
the Bath and West Society, the
Shropshire and West Midland Society,
and the Three Counties Society.

r. and Mrs. Tinsley did all they could to make me feel at home. She was rather shy and had bought a number of books on art and read them carefully, so as to make me feel at ease while conversing with her. Mr. Tinsley was a typical gentleman-farmer, sporting riding-breeches and buttoned gaiters at all hours. He did everything possible to facilitate my work.

The bull was magnificent, and to quote the catalogue of my 1925 London show: "The Hereford . . . [is represented by] Twyford Fairy Boy, whose dark-red coat contrasting with his white head, legs and tail, is almost as curly as that of a sheep." [See p. 7.]

This bull, like the Aberdeen Angus, was very quiet, a fact perhaps due to his excessive fat, which seems essential for showing purposes, but, I am told, is detrimental to super-efficient breeding.

My host told me that when selling livestock to customers, dealers usually try to show their animals at dusk, the evening light seeming to envelop them, simplifying details and making them assume majestic proportions; this point of view was of great interest to me, because I likewise prefer to show a finished statue at the same time of day.

I also began a Hereford Cow at Twyford, but as in the case of other models I did not like it in the end, and so never finished it. I came to

the conclusion that the Hereford being a distinct beef-breed, it would be sufficiently represented by the bull.

It is the custom in an English house for the valet to bring you an early cup of tea, accompanied by one or two thin slices of buttered bread. This fortifies you before you get up and dress. You then proceed to the dining-room where an elaborate breakfast awaits you, beginning with porridge and cream followed by eggs and bacon, sausages (usually on Sundays), liver and bacon, etc. All this is on the sideboard for you to help yourself; after that comes toast with jam or marmalade. The morning following my arrival, I would not go down for the big breakfast, making do with the cup of tea and the slice of bread and butter.

"What! Is that all you have for breakfast?" the anxious hostess exclaims.

I would reply that, living in France, I am quite satisfied with a Continental breakfast.

"But surely you won't refuse a boiled egg and some marmalade, if we send it up with your tea?"

Not taking "No" for an answer, she sends up the tea next morning, accompanied by boiled eggs and bacon, and some delicious home-made jam or marmalade.

At some houses, the Emmets', Brasseys' and Harrisons' for example, you were, of course, asked where and at what time you would like your breakfast. It was amusing and interesting going to these different places, all new to me. In a number of them, I made good and lasting friends such as one can make in England and at whose houses, even after years of absence, one invariably found a sincere a warm welcome.

Of Twyford Fairy Boy I made one large bronze, cast by Valsuani by the *cire perdue* process, horns and hoofs gilt, and beautifully patinated in light green and reddish-brown; light green for the head, legs and tail,

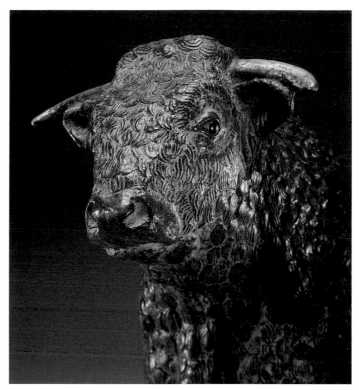

Twyford Fairy Boy

as a reminder of the white markings, the rest in reddish-brown. It was
one of Valsuani's best patinas.

As pendants to the Angus Bulls in black marble, I did one in dark-
red antique Greek marble for the late Douglas Fairbanks, . . . another
for the John Garretts, and one in bronze for Clarence Dillon.

While in the U.S. from 1940 to 1947 I tried the experiment of having
a black antique Chinese lacquer finish made on a bronze subject by a
very clever Japanese artisan who usually restored Coromandel screens
for museums and private collectors. He did this very successfully, with
purplish reflection seen through the black, recalling similar tones on
the surface of a living Angus in the sunshine. This bronze was pur-
chased by Mrs. Vincent Astor.

SHORTHORN BULL

Bridgebank Paymaster

He was probably one of the finest examples of his kind ever bred in our times, and besides his own achievements in the show ring was the sire of many winners both in Great Britain and in the Argentine.

He was a reddish-roan, of monumental proportions. In the catalogue of my 1925 London Exhibition, he is thus described: "The Champion of the Shorthorns, another Scottish breed, executed in red marble, is Bridgebank Paymaster, a magnificent specimen, whose double victory in England and Scotland in three successive years is still remembered by the aficionados of the show ring." [See p. 7.]

The line of his back was absolutely horizontal, his finely carved head well set on his shoulders, the line of his contour from chin down and up, and down again around his brisket, were an invitation to a sculptor to try to immortalize him.

I could not get at him quickly enough and worked indefatigably from early morning till nightfall. Although conditions were unfavourable, the fact of having to overcome them spurred me on to greater and greater activity.

I was living at a comfortable commercial-travellers' inn at Stranraer and had to motor thirty miles every morning to the farm; my lunch was a sandwich which I brought with me. At dusk I would motor back

Shorthorn Bull:
Bridgebank Paymaster

Red Acajou marble
19 ½ x 11 x 27 INCHES
(49.5 x 27.9 x 68.6 CM)
SIGNED AND DATED:
HASELTINE/MCMXXX
VIRGINIA MUSEUM OF FINE ARTS,
THE PAUL MELLON COLLECTION, 86.140

SIRE: *Gainford Ringleader.*
DAM: *Princess Christina. Calved 1919.*
Bred and owned by Albert James Marshall, Bridgebank, Stranraer, Scotland. First and Champion at the Show of the Royal Agricultural Society of England, 1921, 1922, and 1923. First and Champion at the Show of the Highland and Agricultural Society of Scotland, 1921, 1922, and 1923.

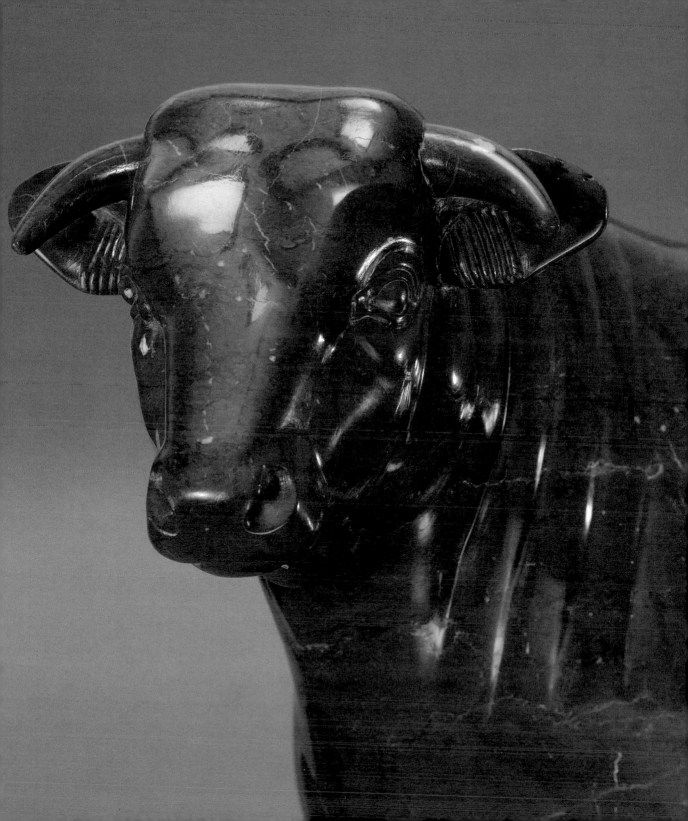

to the inn and have my evening meal. Mr. Albert Marshall, the owner of Bridgebank Paymaster, came to some of these evening meals. He was considered to be the greatest expert on Shorthorns, and went in exclusively for rearing bull calves, which fetched the highest prices in the markets, sons of Bridgebank Paymaster being sold for as much as $1,000 each, at that particular time. . . . He frequently went to the Argentine to judge in the big agricultural shows. He was a great character and considered very shrewd in business; a good storyteller, at supper it was he who held the centre of attention. . . .

I was visualising [a good time at Buck's] and saying that Stranraer would soon be a thing of the past and how good those fat oysters would taste, when the boy who was holding the bull turned his massive charge around in his stall for me to work on his other side, and miscalculated the distance from my model. Bridgebank hit it with his mighty shoulder and down went model, stand and all. When I picked up the debris, the distorted plaster looked like a dying giraffe.

"Greed must be punished," flashed through my mind. It was my German governess's remark many years ago, when I carefully arranged around the rim of the plate the raisins I had picked out of the cake I was eating, looking forward to falling on them in one fell swoop, when the cake was finished. "Greed must be punished," she said, as she took away the plate, raisins and all.

The farm-lad was aghast; his eyes were full of tears and no doubt he expected an outburst of rage on my part. The comical side of the situation struck me and I consoled him by saying that it was nothing and the damage could easily be remedied. We picked up the model, then without losing a minute or stopping to think about the disaster, I set to work on remodelling the whole statue from the deformed and grotesque-looking mess. Next day, to everyone's surprise, including my

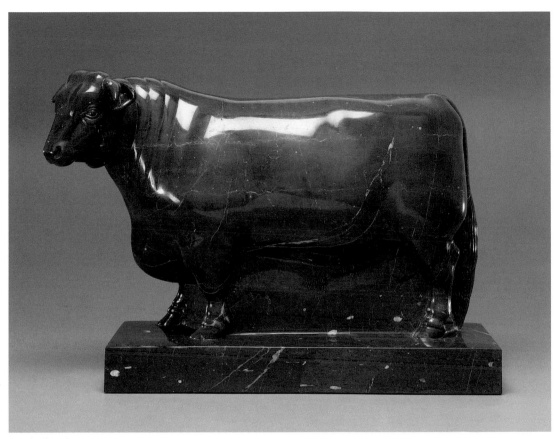

Bridgebank Paymaster

own, it was finished again. Was it better or worse than its predecessor? In any case, it was one of those tours de force of which everyone may be capable under a great nervous strain—a force that is, or should be, latent in everyone and that under provocation or pressure is liable to burst out and assert itself.

Of this model, I made a *rosso antico* marble statue, which formed part of the British Champion Animals collection, and also another one, together with the black marble Angus, for Marshall Field's private collection.

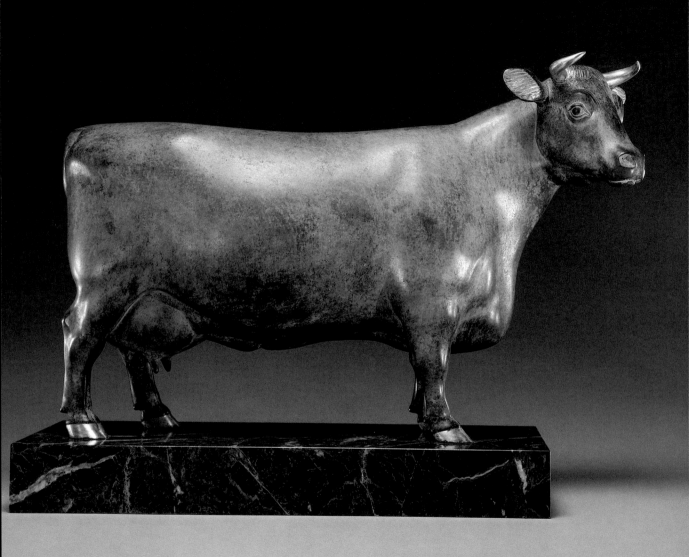

Lily Charter 2nd

Dairy Shorthorn Cow:
Lily Charter 2nd

Bronze, gold plate
14 x 9 ¾ x 26 inches
(35.6 x 24.8 x 66 cm)
Signed and dated:
HASELTINE/MCMXXXIII
Virginia Museum of Fine Arts,
The Paul Mellon Collection, 86.142

sire: *Thorneycroft Richard.*
dam: *Lily Charter. Calved 1916.*
Bred by Frank Bird, Mill Lane, Neston,
Birkenhead, England. Purchased as a
calf at two months old by the Duke of
Westminster, Eaton Hall, Cheshire,
and in 1923 by Lawrence Hignett,
Hook End, Checkendon, Reading.
Silver Challenge Cups at the Show
of the Royal Agricultural Society of
England, 1923.

The beef breeds being disposed of, we can now turn to the solitary cow in the collection of British Champion Animals, namely the Dairy Shorthorn, Lily Charter 2nd. . . .

I returned to Reading to do this model, this time staying at the comfortable home of Mr. Lawrence Hignett. I had an attractively decorated room, the food was excellent and every facility was given me for my work, which made my stay at Hook End very pleasant.

Lily Charter 2nd was a magnificent specimen of a dual-purpose breed, milk and beef, though as far as looks are concerned, I personally prefer the Jersey, Guernsey and Dexter breeds. I find their heads breedier-looking and more in harmony with their bodies. The cow had too thin a neck, like an ox, and its bones and hollows seemed to appear where they should not. But this is purely a personal point of view.

The manager of the herd was a Mr. Crow. He was supposed to be one of the leading authorities in the country in the breeding and showing of Dairy Shorthorns. He was very interested in my model, and was of great assistance to me in drawing attention to the good and bad points of the cow, suggesting the points that might be emphasized, or altered, in order to produce the perfect animal, which was what I had been aiming at in all my models.

Wherever I went to work I let it be known sooner or later that I was an American. I thus anticipated the otherwise inevitable criticisms of Americans, which would have given me the choice between being involved in an unpleasant discussion, or of clearing my throat and revealing my nationality, thereby causing embarrassment to the company! The other solution would have been to keep silent and pretend I was English, which would not have been exactly the thing to do!

One night at the Hignetts, the conversation turned to the subject of an English horse which had been sent to the United States to run in a match against Zev, the best American horse of the year. Zev, as everyone knows, won. Then a guest who had been invited for dinner came out with the remark that even if the British horse had been winning, some "blasted American" would have stuck out his umbrella and tripped him up. The young Hignetts looked at me and I laughed; so they laughed. The guest asked what the joke was. When I told him, he was very much embarrassed and apologized for his faux pas. "But," I added, "where you were really mistaken, was about the umbrella. Perhaps only one American in ten million is ever seen carrying that weapon!"

Dairy Shorthorn Cow, Lily Charter 2nd

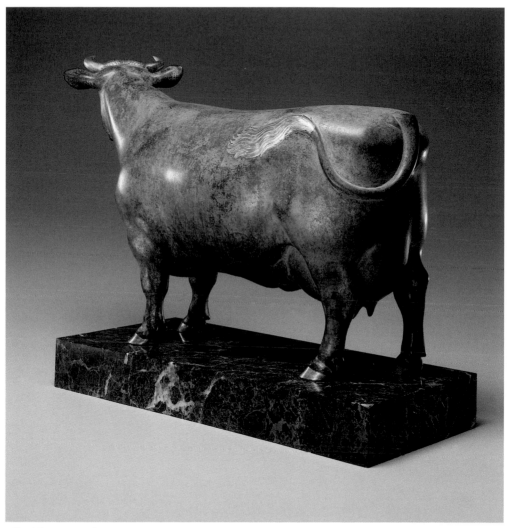

Lily Charter 2nd

Conqueror and Challenger

Lincoln Ram:
Conqueror

Burgundy limestone
14 X 9 ½ X 14 INCHES
(35.6 X 24.1 X 35.6 CM)
SIGNED AND DATED:
HASELTINE/MCMXXXIII
VIRGINIA MUSEUM OF FINE ARTS,
THE PAUL MELLON COLLECTION, 86.143

SIRE: *Pattern Squire. Born 1921. Bred by C. W. Tindall and owned by C. W. Tindall and Major W. H. Rawnsley, at Thornton House, Horncastle, England. First and Champion at the Show of the Royal Agricultural Society of England, 1921. First at Lincoln Show and Sale, 1921. First and Champion at the Yorkshire Show, 1922.*

Lincoln Ram:
Challenger

Burgundy limestone
13 X 6 ½ X 16 INCHES
(33 X 16.5 X 40.6 CM)
SIGNED AND DATED:
HASELTINE/MCMXXXIII
VIRGINIA MUSEUM OF FINE ARTS,
THE PAUL MELLON COLLECTION, 86.144

SIRE: *Dowsby Pride. Born 1920. Bred by C. W. Tindall and owned by C. W. Tindall and Major W. H. Rawnsley, at Thornton House, Horncastle, England. First Two-Shear and Champion at the Show of the Royal Agricultural Society of England, 1922. First at the Lincolnshire Show, 1922. Second and Reserve Champion at the Yorkshire Show, 1922.*

On my list of animals for the British Champion Animals collection was a Lincoln Ram, a breed famed for its wool, both as to quantity and quality.

To do this model I had to make the long journey from London to Horncastle. . . .

The next morning I was taken in a dog-cart to the farm, where I was overcome by the massiveness and simplicity in line of my model, which already looked as if it had been carved in stone by an Egyptian sculptor. . . .

I lost no time in starting on him and as in the other cases, the shepherd in charge was very helpful in pointing out the good and bad points of the breed.

I was also introduced to a brother of Conqueror, one year older than he, and decided to make a model of him too, while I was there, as I thought they would look very well as a pair. So one day I would work on Conqueror, the other on Challenger. The latter was born in 1920. . . . He was the property of the same owners as Conqueror.

I used to concentrate on talking sheep to the shepherds, because I found them very interesting for the gleaning of information which would help my work. I did likewise with herdsmen for cattle, and studgrooms and stable-lads for horses of different breeds. These men

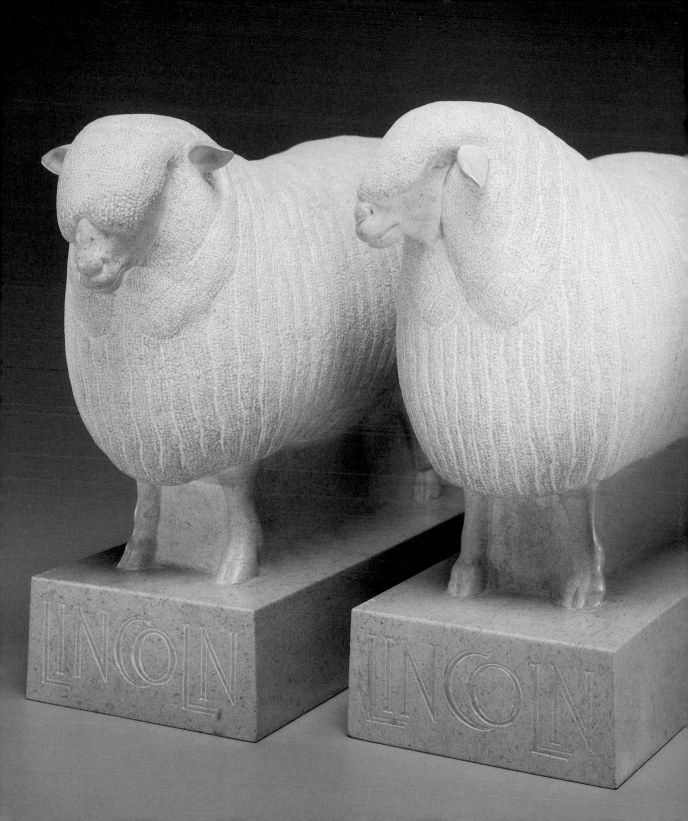

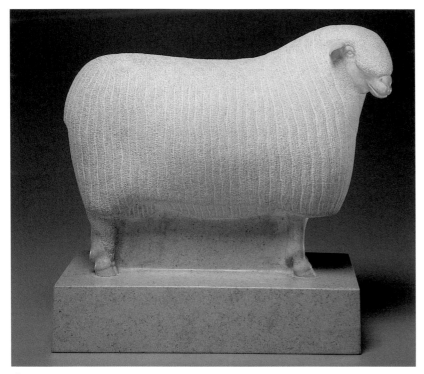

Conqueror

always enjoyed talking about their animals, and they gave me frank, unbiased criticisms, which I felt were absolutely sincere, and to the point; this was in distinct contrast to some of the far-fetched criticisms by the high-brow professional critics.

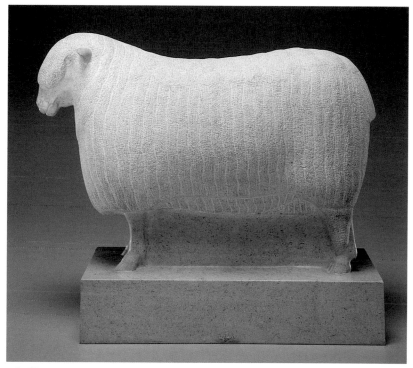

Challenger

I arranged to have lunch at the farm and in the evening a sort of high tea with eggs, before being driven back to my hotel. The two joint owners of the rams dropped in one afternoon to see my work and to say, "How do you do" and "Good-bye."

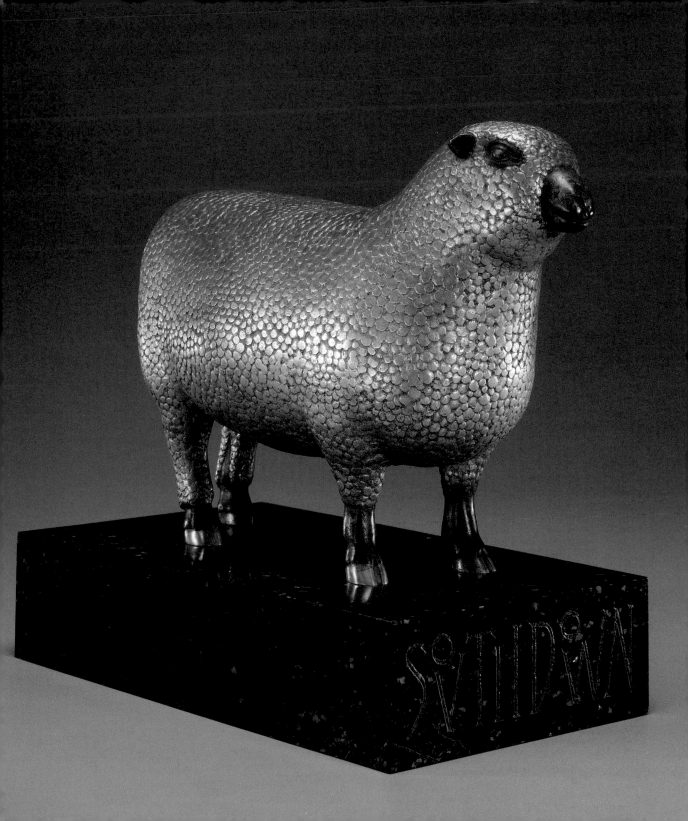

Sandringham Ewe No. 10 of 1921

Southdown Ewe:
Sandringham Ewe No. 10 of 1921

Bronze, gold plate
10 X 6 X 12 INCHES
(25.4 X 15.2 X 30.5 CM)
SIGNED AND DATED:
HASELTINE/MCMXXXIII
VIRGINIA MUSEUM OF FINE ARTS,
THE PAUL MELLON COLLECTION, 86.145

SIRE: *Goodwood 68 of 1919.* DAM:
*Sandringham 24 of 1919. Bred and
owned by His Majesty King George V.
One of the Champion Pen of Ewes at
the Show of the Royal Agricultural
Society of England, 1922.*

This model took me back to Sandringham and to the Feathers Inn, also to the helpful Mr. Beck, the Agent.

The shepherd in charge was the son-in-law of the one in Horncastle, but he had the greatest contempt for the Lincoln, as compared to the Southdown, as far as the meat is concerned.

In the catalogue of my 1925 London Exhibition, Sandringham Ewe's description runs as follows: "The Sheep are also well represented by the two Lincoln rams, celebrated for the luxuriance and quality of their wool, and by the Southdown, whose meat is so highly esteemed that their breeders consider that of the former they are only fit to furnish candles to light the banquet at which Southdown mutton is consumed."

I dined several times with the King's gamekeeper, who with his shaven upper lip and bearded chin looked something like Disraeli. I still have an excellent recipe for Jugged Hare that he gave me.

BERKSHIRE BOAR

Highfield Royal Pygmalion

And now to the pigs (or hogs, as they are called in the U.S.A.), the last three items in my collection of British Champion Animals.

I went up to Leeds, Yorkshire, for the Berkshire Boar, Highfield Royal Pygmalion. . . .

I arrived at the station on a Bank Holiday and the platform was packed with a milling crowd of holiday-makers. I knew that Mr. Townend was to meet me, but how were we to recognize each other? For my part, beardless and not wearing the artist's beret and velvet trousers, I would not easily be spotted, and as for Mr. Townend, how would a pig-breeder look? Then I suddenly saw a stout, roseate gentleman, with small eyes and turned-up nose, double chin protruding from his collar, and went straight up to him and said, "Are you Mr. Townend?" He seemed surprised at my discovering him amongst the crowd, but I did not tell him the reason.

The weather was bleak and misty, [and] Mr. Townend suggested my putting up my modelling stand near the window in his study; he would stay outside with the posing pig. This was quite satisfactory for me, but I am afraid he must have found it very cold. I used to have lunch with Mr. and Mrs. Townend. Mrs. Townend was also stout, and our fare was either pork chops, ham, or pork sausages, so I was always in the right atmosphere!

Berkshire Boar:
Highfield Royal Pygmalion

Bronze, gold plate
11 x 6 ½ x 17 INCHES
(27.9 x 16.5 x 43.2 CM)
SIGNED AND DATED:
HASELTINE/MCMXXXIII
VIRGINIA MUSEUM OF FINE ARTS,
THE PAUL MELLON COLLECTION, 86.148

SIRE: *Pygmalion.* DAM: *Eaton Princess Royal Third. Bred and exhibited by Frank Townend, Highfield, Moor Allerton, Leeds, England, and owned by the Duke of Westminster since 1923. First and Breed Champion at the Show of the Royal Agricultural Society of England, 1922. First and Champion at the Yorkshire Show, 1922.*

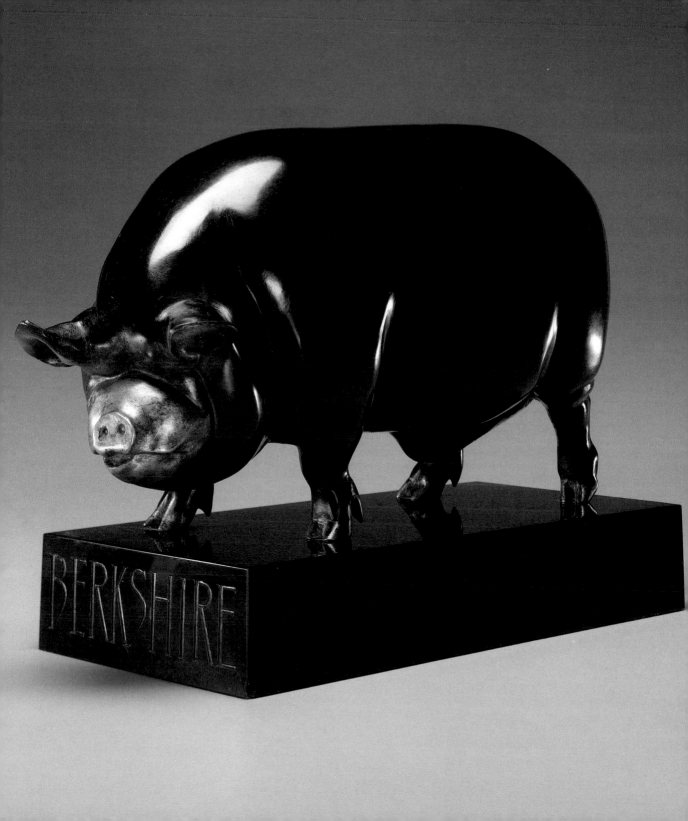

I was surprised to discover that pigs are really very clean animals, if given a chance. Highfield Royal Pygmalion did not reside in a sty, but in a box-stall in the stable where the horses lived. He had immaculate straw to stand and lie in, and, to use parlance, was perfectly house-trained. When nature called, he would open the door of his stall by lifting the latch with his nose, walk out of the stable, cross a courtyard, then a lane, go into a field on the other side and—admire the scenery meanwhile! The word "admire" is really a figure of speech, because the boar was completely blinded by his fat, that is to say, not literally blind, for he could see when the rolls of fat which covered his eyes were momentarily drawn apart. If I remember rightly, when too old to breed, this sympathetic porker was not sent to the butcher, but was allowed to die quietly at the close of his distinguished career. He was buried in Mr. Hignett's [Townend's] garden and an appropriate tombstone was erected over his grave.

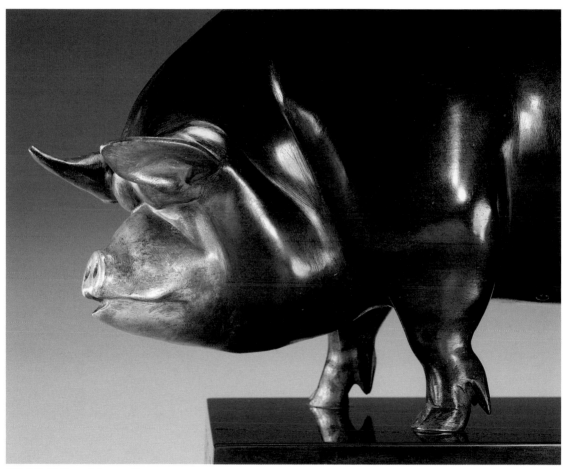

Highfield Royal Pygmalion

Wharfedale Deliverance and Wharfedale Royal Lady

The Middle White boar, like the Champion Berkshire, could not see for his fat. He became very attached to me, because I used to feed him bits of sugar, which in his long and successful career as an exhibitionist and sire, nobody, I am sure, had ever thought of offering him!

Wharfedale Deliverance had small and elegant cloven feet and it hardly seemed possible that they could support the mountains of fat towering above them. The edges of his hieroglyphically curled ears were covered with a fringe of white curls, and his tail was hairy, like a horse's, the hairs nearly touching the ground while he was standing still, and carried gracefully over his back when walking. I represented the tail in that position. Some visitors to the farm noticed this and when they expressed their surprise, I had him walked about—and up went the tail!

In charge of Wharfedale Deliverance was the herdsman's son, who had a whole-hearted adoration for the old boar—in fact, he looked like him. Once, when there was a question of selling the animal, the boy declared he would immediately leave Mr. Paget's service if the boar was sold.

The Champion had three white moustaches on each side of his upper lip. His eyes closed by his fat and his bloodshot countenance reminded me of the old club-men, still going strong in Peter Arno's cartoons in the *New Yorker*.

Middle White Boar:
Wharfedale Deliverance

Rose St. Georges marble
13 X 6 ¾ X 18 ½ INCHES
(33 X 17.2 X 47 CM)
SIGNED AND DATED:
HASELTINE/MCMXXXIII
VIRGINIA MUSEUM OF FINE ARTS,
THE PAUL MELLON COLLECTION, 86.146

Bred and owned by Leopold C. Paget, Middlethorpe Hall, York, England. First at the Royal Lancashire Show, 1920. First and Reserve Champion at the Show of the Royal Agricultural Society of England, 1921. First and Champion Boar at the Show of the Royal Agricultural Society of England, 1922 and 1923. First and Reserve Champion (being beaten by his own daughter, Wharfedale Radiance) at the Yorkshire Show, 1922. Reserve Champion of his breed at the Show of the Royal Agricultural Society of England, 1922 and 1923 (being beaten by his daughters, Wharfedale Radiance and Wharfedale Royal Lady, respectively). First and Champion at the Yorkshire Show, 1923.

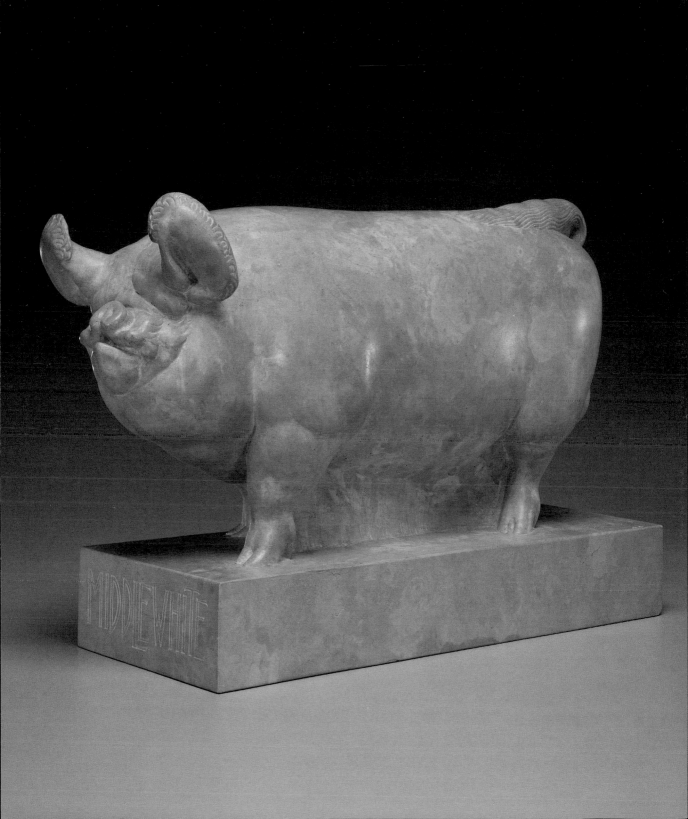

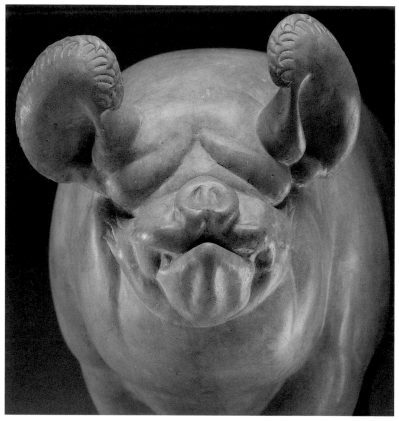

Wharfedale Deliverance

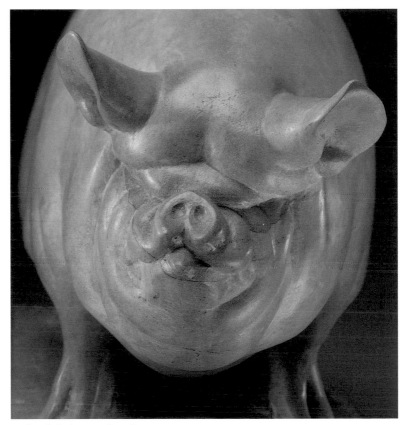

Wharfedale Royal Lady

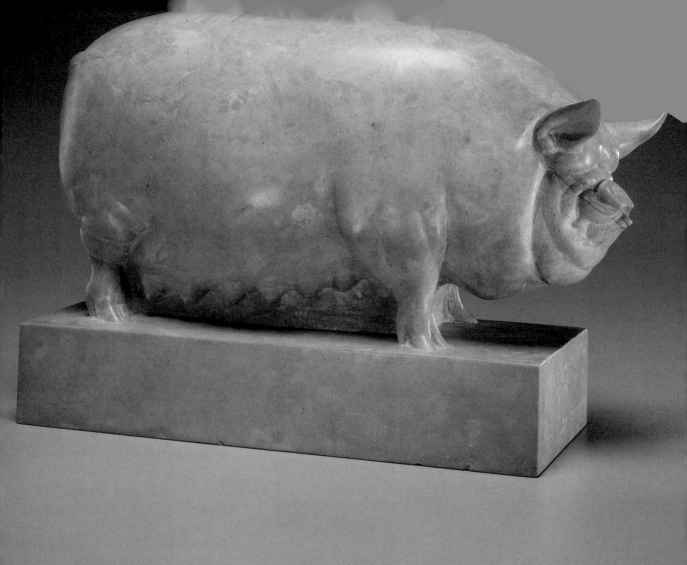

One afternoon when I was getting ready to resume work, I heard the most terrific groans, squeals, snorts and pants coming from his sty. What dire tragedy was taking place? Was my friend being tortured or even murdered? I hastened to his aid, only to behold the consummation of one of the spring marriages, aided and abetted by the herdsman and his son. "He's been at it for over half-an-hour," said the director of the ceremonies. "If we don't take 'im away, 'e'll likely go on all day!" So the performance ended, much to the gallant moustachioed boar's regret, and he was led back to his quarters.

WHARFEDALE ROYAL LADY

As I have said, I was scheduled to do the boar only, but I was so taken by the beauty—beauty from the sculptural point of view—of one of Wharfedale's daughters, Wharfedale Royal Lady, that I stayed on to make a model of her also.

She had the same characteristics as her father—the same straight back, the same type of shortened turned-up nose, and vision blocked out by the rolls of fat surrounding her eyes.

I was impressed by the very Chinese look in the countenance of the Middle Whites; this was explained when I heard that they were originally a Chinese breed, imported into Yorkshire in the eighteenth century. They were supposed to have been much smaller in those days, but thanks to Yorkshire's climatic conditions, selective breeding and the best of nutrition, they have developed into the magnificent and savoury specimens of today.

Besides conforming to the general type prescribed by the British Pig Dealers Association, the herd belonging to Mr. Paget had certain facial characteristics of its own, a family likeness, as it were—and when he saw at an agricultural show a glamorous porcine specimen embody-

Middle White Sow:
Wharfedale Royal Lady

Rose St. Georges marble
11 ½ x 6 ½ x 16 inches
29.2 x 16.5 x 40.6 cm
Signed and dated:
Haseltine/MCMXXXIII
Virginia Museum of Fine Arts,
The Paul Mellon Collection 86.147

Bred and owned by Leopold C. Paget, Middlethorpe Hall, York, England. First and Breed Champion at the Show of the Royal Agricultural Society of England, 1921 and 1923. First and Champion at the Yorkshire Show, 1923.

Middle White Sow, Wharfedale Royal Lady

ing these characteristics, Mr. Paget would buy it to join the happy and distinguished family at Middlethorpe Hall.

The herdsman, whose name I forget, would suddenly point to a huge, shiny, pink sow, her fourteen swollen nipples sticking out right and left, her short, up-turned snout glistening with drool, her eyes non-apparent, her blown-out double-chin curving hieroglyphically outward, and exclaim, "Now, this particular one has a typical Paget face!"

One such sow to whom he pointed happened to be Wharfedale Royal Lady, and that is why, carried away by her looks and what she stood for, I decided to make a model of her, for I considered she would serve as an appropriate pendant to her father. She was so flamboyantly pregnant that she could hardly waddle, and therefore made an excellent model. To her also I gave lumps of sugar and although she could not see me, I am sure she would have given me the glad eye, if she had only had the chance. I worked fast, because the herdsman warned me that her deliverance was imminent and I did not want to be obliged to alter the silhouette of her waistline after the happy event! So I concentrated on the lower part of her anatomy, and the morning after I had finished I was informed by Fred that a happy family of seventeen piglets had arrived to bless the home of the happy mother. I mention

Middle White Boar, Wharfedale Deliverance

mother particularly, because papa had many other wives and happy homes, not only at Middlethorpe Hall, but at many other farms.

I had the ambitious idea at first of surrounding mamma with her offspring, but as this would have entailed months more work at York, during which the children would have grown by leaps and bounds, thus creating endless confusion in the proportions of my models, I abandoned the project.

It was astounding the way every hour, and to the minute, the sow would lie down on her side, as an invitation to her squirming offspring to attack greedily the well-attended milk-bar. After a certain number of minutes of feeding, the sow would shake them off, the children would resume their antics or take a siesta, then an hour later be at it again.

It was very difficult to see the sow's feet properly, as they were so close to the ground and it was too complicated an operation for me to wallow in the bedding in order to obtain results, so I hit on the idea of getting some Middle White pig's feet at the local butcher's shop and having them cast in plaster for future reference.

Thus ended my work in the British Isles in connection with the British Champion Animals.

Suggested Readings

Armstrong, Tom, et al. *200 Years of American Sculpture.* New York: Whitney Museum of American Art, 1976.

Connfer, Janis, and Joel Rosenkranz. *Rediscoveries in American Sculpture: Studio Works, 1893–1939.* Austin: University of Texas Press, 1989.

Penny, Nicholas. *The Materials of Sculpture.* New Haven and London: Yale University Press, 1993.

Ward, Meredith E. *William Stanley Haseltine (1835–1900) and Herbert Haseltine (1877–1962).* Exhibition catalogue. New York: Hirschl & Adler Galleries, Inc., 1992.